MISTER HOLGADO

Christopher William Hill

MISTER HOLGADO

OBERON BOOKS
LONDON

WWW.OBERONBOOKS.COM

First published in 2013 by Oberon Books Ltd
521 Caledonian Road, London N7 9RH
Tel: +44 (0) 20 7607 3637 / Fax: +44 (0) 20 7607 3629
e-mail: info@oberonbooks.com
www.oberonbooks.com

A catalogue record for this book is available from the British
Library.

PB ISBN: 978-1-84943-460-7
E ISBN: 978-1-84943-781-3

Cover illustration © James Illman

Printed, bound and converted
by CPI Group (UK) Ltd, Croydon, CR0 4YY.

Visit www.oberonbooks.com to read more about all our books
and to buy them. You will also find features, author interviews and
news of any author events, and you can sign up for e-newsletters
so that you're always first to hear about our new releases.

For Samuel

Mister Holgado was first performed at the Unicorn Theatre, London on 24 March 2013 with the following cast:

DOCTOR/HOLGADO Sandy Grierson
CONRAD Daniel Naddafy
MOTHER Cath Whitefield

Directed by Matthew Lenton
Set, Costume and Lighting by Kai Fischer
Sound and Composition by Mark Melville

UNICORN

The UK's leading theatre for young audiences

The Unicorn Theatre is the UK's leading theatre for young audiences, serving over 70,000 children, young people and families every year through its professional performances, participation and other events.

Founded in 1947 by Caryl Jenner, the company originally operated out of the back of a van, and toured theatre for children into schools and community centres. The Unicorn was subsequently based at the Arts Theatre in London's West End for many years, before moving into its current home at London Bridge in 2005. Today, the Unicorn building has two theatres, two rehearsal rooms and four floors of public space dedicated to producing and presenting work for audiences aged 2 to 21.

It is a central part of the Unicorn's mission to commission new work, to tour, to be accessible to all and to encourage exchange and collaboration between theatre-makers from different countries and traditions, coming together to develop ideas and projects.

unicorntheatre.com

Box Office 020 7645 0560
147 Tooley Street, London SE1 2HZ

Charity number: 225751
Company number: 480920

Characters

CONRAD

DOCTOR/HOLGADO

MOTHER

Act One

SCENE ONE

The interior of the Van der Bosch apartment in the city of Schwartzgarten. The feel of the apartment is early twentieth century, with odd architectural flourishes which would seem to indicate an Eastern European setting.

Stage right, a kitchen/dining room is dominated by a large square table. A door leads to the world outside, and an upstage doorway leads towards two unseen bedrooms. The kitchen leads, via a hallway, to a small bedroom, stage centre, with a bed and a large painted wardrobe upstage. Beside the bed is a table and lamp.

DOCTOR VAN DER BOSCH's study is located stage left, with a desk, a leather couch, and bookcases which reach to the ceiling. The room is almost filled to overflowing with neatly stacked books. A number of large, brightly painted African tribal masks hang from the walls, along with framed cases of beetles.

It is a drab and austere apartment, decorated in dull green and brown hues and dimly illuminated by antiquated electric light bulbs. In short, it is not an apartment in which a small boy can live happily.

There is a telephone in the kitchen and another in the study. From time to time the lights in the apartment flicker and crackle – this continues throughout the play.

CONRAD hides under the dining room table: all that can be seen are his legs sticking out from under the tablecloth.

MOTHER enters from the upstage doorway. She notices CONRAD hiding under the table.

MOTHER: Conrad?

> *She plays along, pretending to look for him.*

> Where can little Conrad be? Is he in the cupboard? No. Is he under the sink? No. Is he behind the door? No. Is he under the table…?

She lifts the tablecloth and CONRAD springs out, wearing a large and terrifying African mask. In his hand he holds an unusual tribal bust, with hollow eyes and sharp painted teeth. MOTHER shrieks. CONRAD takes off the mask.

CONRAD: Mother?

MOTHER: Paper bag…paper –

CONRAD passes her a brown paper bag.

Calm. Breathe in…

She does so.

And out…

CONRAD: Better?

MOTHER: Much better.

She takes another gasp of air.

I wish you wouldn't scare me like that. You know I get… nervous.

CONRAD: Sorry, Mother.

A factory whistle is heard from outside – a ghastly, almost bloodcurdling noise. Beat. The key turns in the front door.

MOTHER: It's your Father.

Anxiously.

Quickly…back to your room…

But it's too late. The door opens and DOCTOR enters, wearing his hat and coat. He carries a black umbrella and attaché case.

DOCTOR: Good evening my dear, good evening, Conrad.

He kisses MOTHER on the forehead.

MOTHER: Did you have a good day?

DOCTOR: I visited a very strange little girl. She thought her parents were trying to kill her. The child is perfectly

deranged, of course. Her parents are charming people…
very polite and tidy. Their apartment is very well
organised.

MOTHER: Can you make the girl better?

DOCTOR: I am the child's psychologist. Of course I will make
her better.

MOTHER takes another gasp of air from the paper bag.

Are you unwell?

MOTHER smiles, anxiously.

What have you done to your mother, Conrad?

CONRAD: Nothing.

DOCTOR: Have you been studying hard?

CONRAD: Yes, Father.

DOCTOR: You finished on the dot of six, as the factory whistle
blew?

MOTHER gives a watery smile, CONRAD hangs his head.

You know the rules, Conrad. Study until the factory whistle
blows, not a minute earlier.

CONRAD: Yes, Father.

DOCTOR: What are you holding behind your back?

CONRAD holds out the African mask and the carved bust.

What have I told you about playing in my study?

CONRAD: I was looking for a book about tigers.

DOCTOR: That's no excuse. No excuse at all.

He takes the mask and bust from CONRAD.

These are very old and expensive artefacts.

CONRAD: Yes, Father.

DOCTOR: They are not toys.

CONRAD: No, Father.

DOCTOR: Come with me.

> *CONRAD and MOTHER follow DOCTOR into the study.*

> There are things that children should not play with. Valuable things that can easily be broken.

> *He hangs the mask back on the wall.*

> I will not tell you again. Is that understood?

CONRAD: Yes, Father.

DOCTOR: Very good.

MOTHER: *(Anxiously.)* Maybe if you and Conrad played games together…perhaps it would keep Conrad occupied?

> *CONRAD looks delighted.*

DOCTOR: I don't feel comfortable playing games.

> *CONRAD lowers his head, dejected. Beat.*

MOTHER: Quickly, darling. Get ready for bed and I'll read you a story.

CONRAD: Goodnight, Father.

DOCTOR: Goodnight, Conrad.

> *Stiffly, DOCTOR shakes CONRAD by the hand. CONRAD enters his bedroom and gets ready for bed. DOCTOR sits at his desk and takes a box out of his attaché case. He opens the box and observes the contents, making notes in a small pocket book.*

> *MOTHER enters CONRAD's bedroom.*

MOTHER: Now, what shall I read to you?

CONRAD: *(Climbing into bed.) Lucien And The Tiger?*

MOTHER: Isn't that a little young for you?

CONRAD: Please?

MOTHER smiles. She takes a picture book from CONRAD's bedside table.

MOTHER: With the noises?

CONRAD nods. MOTHER picks up a small box from beside the bed – by turning it upside down it produces a loud tiger growl. MOTHER turns the box every time a tiger is mentioned in the story.

MOTHER: Once upon a time in a land that was very strange lived a little boy called Lucien... Lucien lived in an apartment with his mother and father and a Bengal tiger... The tiger was Lucien's very special friend... Lucien and the tiger went everywhere together... They went to school together... They went to the park together... They visited the zoo together... And at night, when Lucien went to bed, the tiger slept on a rug on the floor... And as Lucien's parents came to kiss him goodnight they said, 'Isn't Lucien lucky to have a Bengal tiger as his very special friend?' ... And Lucien and the tiger lived happily ever after... The end.

CONRAD: What do tigers eat, Mother?

MOTHER: If I was a tiger I'd like to eat chocolates.

CONRAD: What sort of chocolates?

MOTHER: Champagne truffles?

CONRAD: Yes. That's what tigers eat. Champagne truffles.

MOTHER: Oh, good.

CONRAD: Can I have a tiger, Mother?

MOTHER: Perhaps. When you're older.

CONRAD: Can't I have a tiger now?

MOTHER: The apartment's too small. Where would a tiger live?

CONRAD: On top of the wardrobe. He could make sure nobody was hiding inside.

MOTHER: There wouldn't be room for a tiger on top of the wardrobe.

CONRAD: Where do tigers live?

MOTHER: In the zoo.

CONRAD: I'd feed the tiger and give it a bowl of milk every morning…and champagne truffles.

MOTHER: I don't think you're being very sensible. What would your father say? If he came home to find a tiger living in your bedroom?

CONRAD: He'd be cross.

MOTHER: He'd be very cross.

CONRAD: Yes.

Pause.

Maybe if it was just a small tiger?

MOTHER: You know we can't keep animals in the apartment.

CONRAD: I'd take the tiger for walks.

MOTHER: It's a very dangerous place outside, Conrad. There are dangerous things…and dangerous people. And we worry, Conrad, me…and your father.

CONRAD: I'd be very careful.

MOTHER: *(Nervously.)* We wouldn't want anything to happen to our precious little angel. Because dangerous people do dangerous things…dangerously. Do you understand me, Conrad?

CONRAD: No.

MOTHER: I don't feel very well.

CONRAD passes MOTHER a paper bag from the drawer of his bedside table. MOTHER takes two deep breaths of air.

CONRAD: I want to have a very special friend…like Lucien did.

MOTHER: Aren't you happy here?

CONRAD: I just want to go outside.

MOTHER: But we have to protect you, darling.

She kisses him goodnight.

CONRAD: But who's going to protect you, Mother? If I had a tiger you'd always feel safe.

MOTHER laughs, anxiously.

MOTHER: Goodnight.

She switches off the light. The room is plunged into darkness.

CONRAD: Mother…

MOTHER: Yes?

CONRAD: I don't like it when the wardrobe door's open.

MOTHER: But why?

CONRAD: There might be somebody hiding inside, watching me.

MOTHER closes the wardrobe door.

MOTHER: Goodnight, Conrad.

CONRAD: Goodnight, Mother.

MOTHER closes the door. She knocks on the study door.

DOCTOR: Come.

MOTHER enters. DOCTOR does not look up from his writing.

Yes?

MOTHER: I'm worried about Conrad.

DOCTOR: Worried?

MOTHER: I think he spends too much time on his own.

DOCTOR: It's good for the boy. Gives him time to think.

MOTHER: Does he have to think all the time?

DOCTOR: It improves the mind.

MOTHER: Maybe…maybe if we let Conrad play with other children?

DOCTOR stares into the box and continues to make notes.

DOCTOR: That is a very bad and dangerous idea. We must look after the boy…we must save him from himself…and how can we do that if we don't watch him every minute of the day? I don't think it's good for Conrad to play with other children. The noise and disorder…the untidiness.

MOTHER: What is in the box?

DOCTOR: *Megasoma elephas.*

MOTHER: I'm sorry?

DOCTOR takes a pair of tweezers and holds up a large beetle from the box, its legs wriggling.

DOCTOR: A rhinoceros beetle.

MOTHER gasps.

I shall observe it and take notes and when it dies I will have it framed and mounted on the wall with the others.

DOCTOR thrusts the beetle towards MOTHER, who shrieks.

Don't shriek…you'll scare it.

He returns the beetle to the box.

Have you taken your pills?

MOTHER: No.

DOCTOR takes a bottle of pills from a cupboard and pours a glass of water. He places two pills in MOTHER's hand, which she obediently swallows with the water.

DOCTOR: Children are like beetles. They should be placed under the microscope and observed closely. Only then can we hope to understand them.

MOTHER: Can the beetle escape?

DOCTOR: No.

He continues to write.

Is that all?

MOTHER: Yes. I'm sorry to disturb you.

DOCTOR: Please close the door on your way out.

MOTHER: Yes, of course.

She exits and closes the door behind her. She considers entering CONRAD's room, but reconsiders and exits through the offstage hallway. DOCTOR gets up from his desk. He opens the door to check no one is outside. He closes the door and lifts one of the African masks off the wall. He puts the mask on and peers into the mirror. He strikes a terrifying pose, and roars at his reflection – a 'tribal' yell. The noise wakes CONRAD, who sits up in bed.

DOCTOR takes off the mask and laughs. He puts the mask back on the wall. He switches off his desk lamp and exits through the offstage hallway.

In the darkness, CONRAD's wardrobe creaks open. He switches on the bedside lamp and stares in terror at the wardrobe.

SCENE TWO

The following morning. CONRAD enters the kitchen and takes a bowl and a box of champagne truffles from the cupboard.

MOTHER: *(Entering.)* Good morning, Conrad.

CONRAD: Good morning, Mother.

He takes out a bottle of milk and fills the bowl.

MOTHER: What are you doing?

CONRAD: I'm pouring a bowl of milk for my tiger.

MOTHER: But you don't have a tiger.

CONRAD: I do have a tiger.

He picks up the bowl and the box of truffles and walks back to his bedroom. MOTHER follows him, anxiously.

There you are, Sigmund. I've brought you some milk and champagne truffles.

MOTHER: *(Quietly.)* Are you feeling quite well, Conrad?

CONRAD: Very well, thank you, Mother.

MOTHER: But…there isn't a tiger in your bedroom.

CONRAD: Of course there's a tiger.

MOTHER: Please be sensible, darling.

CONRAD: *(Pointing.)* There he is. There's the tiger.

MOTHER: But…I can't see him.

CONRAD: He's moving too quickly.

MOTHER turns quickly.

There he is now, under the bed.

MOTHER: Where?

CONRAD: You're too slow. He's moved again.

Beat.

He's there, Mother…on top of the chair.

MOTHER cries out in alarm. DOCTOR enters from the offstage hallway.

DOCTOR: What's all the noise about?

Beat.

MOTHER: *(Anxiously.)* Conrad has a pet tiger.

DOCTOR: A what?

CONRAD: A tiger, Father. His name is Sigmund. There he is… on top of the wardrobe.

DOCTOR: *(Patiently.)* Where did the tiger come from?

CONRAD: From the zoo.

Beat.

DOCTOR: You want us to believe that a tiger is hiding on top of your wardrobe?

CONRAD: Yes.

Pause.

DOCTOR: Could I talk to you in my study, please?

MOTHER: What? Oh, yes…yes.

DOCTOR takes MOTHER into the study and closes the door. CONRAD eats the chocolates and drinks the bowl of milk. He tiptoes to the study door and listens at the keyhole.

Do you think he's telling the truth?

DOCTOR: Of course he's not telling the truth. I think we'd know if Conrad was keeping a tiger in his bedroom.

MOTHER: But would we? He's a very secretive boy sometimes.

DOCTOR: There would be noises. Roaring…or growling, at the very least.

MOTHER: Surely some tigers are quieter than other tigers? If it was a very quiet tiger, maybe we wouldn't hear it? Conrad used to hide apple cores under his bed…maybe there was a tiger here then? Maybe he was feeding the tiger?

DOCTOR picks up the telephone and dials.

Who are you telephoning?

DOCTOR: The zoo.

MOTHER: But why?

DOCTOR: Good morning. This is Doctor Van der Bosch in apartment 19C, Marshal Podovsky Street…my son informs me that he has a tiger living on top of his wardrobe. He says it came from the zoo. I assume he means your zoo. You don't? Yes, I understand. Thank you. Good morning.

He replaces the receiver.

MOTHER: Well, what did he say?

DOCTOR: What did you expect him to say?

MOTHER: I don't know. I'm not sure.

DOCTOR: The zookeeper says that the tiger is safely in his cage. Now do you believe me?

MOTHER: It isn't like Conrad to lie.

DOCTOR: It's like all children to lie. Children are very dishonest creatures.

MOTHER: Not Conrad.

DOCTOR: All children.

MOTHER: I think he might be lonely.

DOCTOR: Lonely? Of course he's not lonely. He's got his books. How can a boy be lonely with books?

MOTHER: *(Suddenly.)* Maybe there's another tiger…one that they've forgotten about? Maybe it escaped and nobody noticed?

DOCTOR telephones again.

DOCTOR: Again, good morning. This is Doctor Van der Bosch in apartment 19C, Marshal Podovsky Street. My wife wondered if it was possible that you have a second tiger…?

MOTHER: *(Whispering.)* One that they've forgotten about?

DOCTOR: …one that you've forgotten about? Just as I thought. Thank you. Finally, good morning.

MOTHER: No?

DOCTOR: No. The zookeeper assures me that they have one tiger and one tiger only.

MOTHER: So… Conrad is lying to us.

DOCTOR: Either that or the boy is irredeemably maladjusted.

MOTHER: What do you mean?

DOCTOR: That there's something terribly wrong with his brain.

MOTHER: How can we be sure which it is?

DOCTOR: There is only one way to find out. We must talk to him.

CONRAD races back to his room. DOCTOR and MOTHER hurry to CONRAD's bedroom. CONRAD holds out the empty bowl.

CONRAD: Look. Sigmund has drunk all the milk.

MOTHER: What a clever tiger.

DOCTOR: *(Quietly.)* There is no tiger.

CONRAD: The tiger's my friend.

DOCTOR: The tiger is not your friend. You do not have a tiger.

CONRAD: The tiger is called Sigmund.

DOCTOR: There…is…no…tiger.

CONRAD: Then who's eating all the chocolates?

DOCTOR: A very good question.

MOTHER: Darling, your father thinks there might be something terribly wrong with your brain.

DOCTOR: Don't scare the boy.

MOTHER: *(Upbeat.)* You won't die.

Beat.

Will he?

CONRAD: Is there something wrong with my brain, Father?

DOCTOR: I'm not sure yet. Please, step into my study.

CONRAD walks into the study.

Please wait outside.

MOTHER: But –

DOCTOR: Thank you.

He closes the door.

Sit on the couch.

CONRAD does so.

Can you hear me clearly?

CONRAD: Yes, Father.

DOCTOR: Very good.

Pause.

Have you ever had a knock to your head?

CONRAD: No, Father.

DOCTOR: A knock to the head can alter people in very strange ways…it can make them forget all sorts of things. For example, the difference between truth and lies.

CONRAD: But I haven't had a knock to the head, Father.

DOCTOR: Very well.

He takes a strange pair of spectacles out of his desk drawer.

This won't hurt.

He places the spectacles on CONRAD's nose.

CONRAD: What are you going to do?

DOCTOR: It's quite simple. I will hold up a series of cards, and I want you to tell me what you see. Do you understand?

CONRAD: Yes.

DOCTOR: Yes, what?

CONRAD: Yes, Father.

DOCTOR: Then we'll begin.

He holds up the first card.

Well?

CONRAD: Airship.

DOCTOR: Good.

He holds up another card.

CONRAD: Zebra.

DOCTOR: Very good.

Another card.

CONRAD: Piano.

DOCTOR: Excellent.

Another card.

CONRAD: Fire extinguisher.

> *Another card.*

> Alarm clock.

> *Another card.*

> Alligator.

> *Another card. CONRAD is beginning to enjoy himself.*

> Tram conductor.

> *Another card.*

> Gorilla.

> *Another card.*

> Vacuum cleaner.

> *Another card. Suddenly, CONRAD recoils.*

DOCTOR: Yes?

CONRAD: *(Quietly.)* Spider.

DOCTOR: Very good. Actually, it is a bird-eating spider.

> *He removes CONRAD's spectacles.*

> There is clearly nothing wrong with your eyes.

CONRAD: What about my brain?

DOCTOR: Too early to say.

> *Beat.*

> Do you have bad dreams?

CONRAD: *(Nervous.)* No.

DOCTOR: *(Insistent.)* Do you have bad dreams?

CONRAD: Yes.

DOCTOR: Tell me about your bad dreams.

CONRAD: There's a man hiding in my wardrobe. He comes out at night and stands on the floorboard…the one that creaks.

DOCTOR: I see.

CONRAD: It's a frightening wardrobe.

DOCTOR: But wardrobes are not frightening.

CONRAD: Mine is.

DOCTOR: Wardrobes are for clothes. They are not designed to terrify children. What do you say to that?

CONRAD: I don't know.

DOCTOR: You see? You're not as clever as you think.

Beat.

We will now play a game. Do you like games?

CONRAD: *(Enthusiastically.)* Yes, Father.

DOCTOR: I will say a word and I want you to say the first thing that comes into your head. The very first thing. Do you understand?

CONRAD nods.

Then we will begin. River.

CONRAD: Fish.

DOCTOR: Mother?

CONRAD: Chocolate.

DOCTOR: Interesting. Very interesting. Staircase?

CONRAD: Alphabet.

DOCTOR: Father?

CONRAD: Beetle.

DOCTOR: *(Surprised.)* Beetle?

CONRAD: *(Continuing the word association.)* Cobra.

DOCTOR: No, I meant…

> *Beat.*

> We will continue. Ostrich?

CONRAD: Orchestra.

DOCTOR: Wardrobe?

CONRAD: Tiger.

DOCTOR: Mother?

CONRAD: Apple strudel.

DOCTOR: *(Hopefully.)* Father?

CONRAD: Wasps.

DOCTOR: *(Dismayed.)* Mother?

CONRAD: Ice cream.

DOCTOR: Father?

CONRAD: Bird-eating spider.

> *Pause.*

DOCTOR: Tiger?

> *CONRAD takes a moment to think.*

CONRAD: Wardrobe.

> *Beat.*

DOCTOR: Is there a tiger in your bedroom?

CONRAD: Yes.

> *Beat.*

DOCTOR: What is your darkest secret?

CONRAD: *(Embarrassed.)* I sometimes want to bite Mother.

DOCTOR: All little boys want to bite their mothers. It's perfectly natural.

CONRAD: Is it?

DOCTOR: Yes. Have you been studying your books?

CONRAD: Yes, Father.

DOCTOR: Mathematics. What is Pythagoras's theorem?

CONRAD: The square of the hypotenuse is equal to the sum of the squares of the other two sides.

DOCTOR: Is there a tiger in your bedroom?

CONRAD: Yes.

DOCTOR: What is Pi?

CONRAD: The ratio of the circumference of a circle to its diameter –

DOCTOR: *(Interrupting.)* Is there a tiger in your bedroom?

CONRAD: *(Insistent.)* Yes.

DOCTOR: *(Frustrated.)* The correct answer is 'no'. I will ask you again. Is there a tiger in your bedroom?

CONRAD: Yes.

DOCTOR: *(Furiously.)* Is there a tiger in your bedroom?

CONRAD: Yes.

Angrily, DOCTOR slams his fist down on the desk.

Are you unwell, Father?

DOCTOR: No.

CONRAD: Is there something wrong with *your* brain?

DOCTOR: *(Quietly.)* Go to your room.

CONRAD: But, Father –

DOCTOR: *(Angry but controlled.)* You tell lies, and lies are ugly stories…and little boys who tell ugly stories are ugly children. Which of course means, *ipso facto*, you are an ugly child. What do you think of that?

CONRAD: *(Quietly.)* I think Sigmund, my tiger, will be getting hungry now.

DOCTOR: *(Exploding.)* Get out.

CONRAD rises from the couch and opens the door. MOTHER, who has been listening outside the door, almost falls into the room.

CONRAD: Excuse me, Mother.

He walks to his bedroom. MOTHER enters the study.

MOTHER: Was it his brain? Is he ill?

DOCTOR: His brain is functioning perfectly. His hearing is perfect. There is nothing wrong with his eyes.

MOTHER: Then what? What can be the matter with our little Conrad?

DOCTOR: It's quite simple. Conrad has asked for a tiger, you refused to give him a tiger. And now he is attempting to get his revenge by pretending he has a tiger.

MOTHER: So it's my fault?

DOCTOR: We're both to blame. Although I suppose you're more to blame than I am…after all, you were the one who denied Conrad a tiger.

MOTHER: I didn't think you'd approve of a tiger in the apartment.

DOCTOR: Quite right, but that's not the point.

Beat.

You know he wants to bite you sometimes?

MOTHER: *(Anxiously.)* Is that quite normal?

DOCTOR: Of course not.

MOTHER: Then what are we going to do?

Beat.

DOCTOR: We need to invent a plan.

SCENE THREE

That night. CONRAD is in bed. The cuckoo clock strikes one. MOTHER and DOCTOR appear at the upstage doorway wearing dressing gowns.

MOTHER creeps towards CONRAD's bedroom. She listens at the door, but hears nothing. She signals the all-clear to DOCTOR, who takes a box of champagne truffles from the kitchen cupboard. He tiptoes to CONRAD's door, and begins to lay a trail of truffles along the hallway and into the kitchen.

DOCTOR opens the apartment door and leaves it slightly ajar. He walks back to CONRAD's bedroom, followed by MOTHER. DOCTOR opens the door and enters the room. He tiptoes towards the wardrobe – he turns the handle and the door creaks open. CONRAD stirs in bed.

Gently, MOTHER wakes CONRAD.

MOTHER: Conrad, darling. Conrad…

DOCTOR: *(Shouting.)* Wake up!

 CONRAD wakes up, terrified.

CONRAD: Father?

 He sits up in bed.

DOCTOR: Your mother and I have some bad news.

MOTHER: Terrible news.

CONRAD: What's happened?

DOCTOR: Your mother thought she heard noises.

MOTHER: I did.

CONRAD: What sort of noises?

MOTHER: A growling noise…like a tiger.

DOCTOR: It was a tiger.

 CONRAD gets out of bed. He looks up at the top of the wardrobe.

CONRAD: Where is Sigmund?

MOTHER: If your father tells you what happened, will you promise to be very brave, darling?

CONRAD: Father?

DOCTOR: While we were sleeping, a man…a very strange man…let Sigmund, your tiger, escape from the apartment…

CONRAD: No!

DOCTOR: …he left a trail of champagne truffles, leading from the wardrobe to the front door.

CONRAD follows the trail of chocolates all the way to the apartment door.

So, unfortunately your tiger has gone. And that's that.

CONRAD: But Sigmund wouldn't go and leave me on my own.

DOCTOR: Apparently Sigmund liked champagne truffles more than he liked you.

CONRAD: But…where did the man come from?

DOCTOR: *(Deliciously.)* He must have been hiding inside your wardrobe, mustn't he?

CONRAD: What was his name?

MOTHER: His name?

CONRAD: He must have had a name?

MOTHER: His name was…

Beat.

DOCTOR: *(Suddenly.)* His name was Mister Holgado.

Pause.

So now you can go back to bed.

Terrified, CONRAD gets back into bed.

MOTHER: Goodnight, Conrad.

CONRAD: But –

DOCTOR: *(Firmly.)* Goodnight, Conrad.

> *He closes the wardrobe door. MOTHER kisses CONRAD on the forehead, switches out the light and closes the door. DOCTOR and MOTHER exit through the upstage doorway.*

> *There is a creak from the wardrobe. Beat. CONRAD climbs out of bed and creeps slowly towards the wardrobe. He stands on the uneven floorboard, and the wardrobe door swings open with a groan. He screams.*

> *MOTHER and DOCTOR rush back to CONRAD's bedroom.*

DOCTOR: Why aren't you asleep?

CONRAD: Did you hear…?

> *Beat.*

MOTHER: What?

DOCTOR: We didn't hear a thing.

MOTHER: Would you like some hot milk?

CONRAD: I heard a noise.

DOCTOR: What sort of noise?

CONRAD: I don't know. It came from the wardrobe.

> *Beat.*

> I think Mister Holgado is hiding in my wardrobe.

> *Desperately, MOTHER turns to DOCTOR.*

DOCTOR: But I told you…Mister Holgado has *gone*. He let Sigmund escape, and then he went away.

CONRAD: But he came back. It's true…he's hiding inside my wardrobe.

MOTHER: People don't live in wardrobes. People live in apartments, like we do.

DOCTOR: Only strange people live in wardrobes.

MOTHER: People who have something wrong in their heads.

DOCTOR: Sick people.

CONRAD: Mister Holgado doesn't live in the wardrobe. He's just waiting there.

MOTHER: Waiting for what?

DOCTOR: What could he possibly be waiting for?

Pause.

CONRAD: He's waiting to eat me.

MOTHER: Eat you?

CONRAD: With his knife and fork…

Beat.

Like a little bit of meat.

MOTHER: *(Hushed.)* Should we call the police?

DOCTOR: What would we tell them? That Conrad thinks he has a man hiding in his wardrobe?

MOTHER: I would have thought that was a very good reason to call the police.

DOCTOR: I'm sure there's nobody hiding in the wardrobe.

MOTHER: Maybe we should check…just to make sure?

DOCTOR: Very well.

Cautiously, MOTHER steps into the wardrobe.

CONRAD: Be careful, Mother.

DOCTOR: Well? Is there a man hiding inside?

MOTHER: Not that I can see.

She taps the inside of the wardrobe with her hand.

DOCTOR: Anything? Any false panels? Any secret doors?

MOTHER: Nothing.

The door swings shut behind MOTHER.

Beat.

CONRAD: *(Quietly.)* Mother…?

Suddenly, the door rattles and the wardrobe shakes. MOTHER screams from inside. CONRAD tries in vain to open the door.

CONRAD: Get out!

DOCTOR: *(Alarmed.)* What's wrong? What's happening?

CONRAD: Mother!

Silence from the wardrobe.

Beat.

MOTHER opens the door, and steps out, laughing.

DOCTOR: That isn't amusing.

MOTHER: There is nobody inside.

DOCTOR: You see?

MOTHER: It's a perfectly ordinary wardrobe.

DOCTOR: And now you can go to sleep.

MOTHER: Goodnight, my little angel.

CONRAD looks terrified.

DOCTOR: Goodnight.

MOTHER switches out the light.

SCENE FOUR

Morning. The cuckoo clock strikes eight. Quietly, CONRAD opens his bedroom door – there is no one around. He tiptoes into the kitchen and checks that the coast is clear. He opens a cupboard door and removes a jar of jam. He opens a drawer and takes out a knife, a fork and a white napkin. Smiling, he creeps back to his bedroom where he pulls the covers off his bed. He opens the jar and tips the jam onto his pillow. He opens the wardrobe door, checking inside with his torch to make sure it is empty. He takes the clothes out of the wardrobe, and puts them in a pile on the floor. He climbs into the wardrobe and closes the door behind him.

Beat.

MOTHER enters through the upstage doorway. She walks to CONRAD's bedroom.

MOTHER: Conrad. It's time to get up.

> *No answer.*

> Conrad? Are you in there?

> *She enters.*

> Conrad?

> *She notices the covers on the floor and the jam on the pillow, and shrieks. DOCTOR enters, irritated.*

DOCTOR: Why are you making so much noise?

MOTHER: Darling, I think something terrible has happened.

DOCTOR: What is it?

MOTHER: Conrad has disappeared… I think Mister Holgado came out of the wardrobe in the middle of the night and ate him.

DOCTOR: *(Quietly.)* How many times must I tell you…there is no Mister Holgado. We invented Mister Holgado.

MOTHER: But, darling, look at the evidence…the bedclothes on the floor…the blood on the pillow…

The wardrobe door creaks open and MOTHER shrieks again.

DOCTOR: Will you please stop doing that?

He gives MOTHER two pills which she swallows. CONRAD steps out of the wardrobe. He has dressed up to look like Mister Holgado, and has smeared his mouth with jam. He holds the knife and fork from the kitchen and has tucked the now jam-stained napkin into his shirt collar. MOTHER backs away.

MOTHER: What have you done with our darling little Conrad?

CONRAD: I've eaten him with my knife and fork, like a little bit of meat.

MOTHER: *(To DOCTOR.)* There, I told you. You never listen to me. I said he'd eaten Conrad, and I was right.

DOCTOR: Just look at his teeth. Not nearly sharp enough. He couldn't eat a child with teeth like those.

MOTHER: But there's blood all round his mouth.

DOCTOR touches the 'blood' with his finger and tastes it.

DOCTOR: Just as I thought.

MOTHER: What?

DOCTOR: Sour cherry jam.

MOTHER: Jam? Not blood?

DOCTOR: No.

Beat.

This isn't Mister Holgado. It's only Conrad dressed up. Mister Holgado is much more terrifying.

MOTHER stares at DOCTOR in disbelief. DOCTOR observes the pile of clothes on the floor.

Why have you caused such a mess?

MOTHER: You can't leave your clothes on the floor, they'll crease. Very untidy.

CONRAD: The wardrobe isn't so frightening when it's empty.

MOTHER: Your winter coat…your gloves and muffler.

She picks up the pile of clothes and is about to return them to the wardrobe.

CONRAD: No!

MOTHER stops.

Maybe I don't need a wardrobe? Perhaps I could hang my clothes on the back of the chair?

DOCTOR: Nonsense. You'll have a wardrobe like every other child.

CONRAD: But I don't want a wardrobe.

DOCTOR: You are a very ungrateful little boy.

MOTHER returns the clothes to the wardrobe.

CONRAD: *(Desperately.)* He eats cockroaches.

MOTHER: Who does?

CONRAD: Mister Holgado.

DOCTOR: Cockroaches?

CONRAD: *(A flash of imagination.)* In the wardrobe. He's a tall man with black eyes. He waits in the wardrobe to eat me, and while he's waiting he eats cockroaches.

MOTHER: Why?

CONRAD: He gets hungry?

MOTHER: But…cockroaches?

CONRAD: He eats their heads first. Then their shiny little bodies.

MOTHER: How horrible.

She finishes hanging the clothes.

DOCTOR: So, these are the facts, as I understand them. At some time in the past few days, perhaps at night, a tall man with black eyes broke into our apartment. One night, perhaps tonight, perhaps not, the man –

CONRAD: Mister Holgado.

DOCTOR: Mister Holgado will climb out of your wardrobe, while you're asleep…you know the rest, of course.

CONRAD nods gravely. Beat.

Please sit quietly and read a book.

CONRAD sits on his bed and reads 'Lucien And The Tiger'. DOCTOR and MOTHER step into the hall and close the door behind them.

MOTHER: Is there somebody hiding in Conrad's wardrobe, waiting to eat him?

DOCTOR: Of course not.

MOTHER: But what if there is? Maybe he sees somebody that we don't see?

DOCTOR: He's making it up.

MOTHER: *(Rapidly.)* We don't know that. Maybe he's seen someone…someone that frightens him. I would never forgive myself. What if there is a secret panel in the back of the wardrobe…a secret panel that I didn't notice… what if it opens into the apartment next door…what if Mister Holgado waits until we're asleep in bed, then climbs through the door into Conrad's wardrobe, with his knife and…it's too awful to think about…with his knife and fork. What if we wake up one morning, you're sitting at the table eating your breakfast… I call to Conrad… 'Conrad. Your breakfast will get cold.' But there's no answer, and why not? Because Mister Holgado came and ate him in the night…there's nothing left of him. Eaten up. What do we do? Poor little Conrad, eaten…and the neighbours, what do we say to the neighbours? How do we explain that we allowed our own little boy to be eaten…and the police.

Won't the police ask questions? Awkward questions. 'Why didn't you take better care of your little boy?' What will we say?

DOCTOR: You're being hysterical. There is nobody hiding in Conrad's wardrobe. The boy has gone too far.

MOTHER: Too far?

DOCTOR: The matter is more serious than I thought.

MOTHER: He's still cross with us because we let his tiger escape.

DOCTOR: How many times do I have to tell you? There was no tiger.

Beat.

Conrad tells us there is a man hiding in his wardrobe, we tell him there is not. The more we protest, the more he tries to convince us. But if we tell Conrad that Mister Holgado really *does* exist, then Conrad will undoubtedly tell us that the man is only a figment of his imagination.

MOTHER: Ingenious. Do you think it will work?

DOCTOR: Of course it will work. If there's one thing I understand, it's children.

SCENE FIVE

Night. CONRAD is asleep in bed. MOTHER and DOCTOR enter the kitchen. MOTHER holds an old and battered child's doll, DOCTOR opens the pot of jam. With a paintbrush he begins to daub the word 'Holgado' in big red letters on the kitchen wall.

MOTHER: You're sure this is a good idea?

DOCTOR: Remember, I am a child psychologist, you are not. I understand how children's brains work.

Beat.

Now, give me the doll.

MOTHER: I don't think I want to.

DOCTOR: But you must.

MOTHER: If you're sure it's necessary?

DOCTOR: It is.

Reluctantly, MOTHER hands DOCTOR the doll.

MOTHER: *(Gently.)* Her name is Ingrid.

DOCTOR takes a large knife from a drawer. He places the doll on the table, and cuts off one of the arms. MOTHER groans and shuts her eyes. DOCTOR removes the doll's hair and reaches inside the head to pull out one of the glass eyes. He holds up the doll.

DOCTOR: What do you think?

MOTHER moans.

Very good. Now, lock Conrad's door.

MOTHER creeps along the hallway. She takes a key out of her pocket and silently locks CONRAD's door.

Are you ready?

MOTHER: Yes.

DOCTOR begins to walk up and down the hallway, treading heavily on the floorboards. CONRAD stirs in bed.

CONRAD: Mother…?

DOCTOR: It's working.

He begins to stamp on the floorboards – a terrifying noise. CONRAD switches on his bedside lamp. DOCTOR sees the light under the door.

He's switched on the light.

He rushes into the kitchen, and pulls down the handle on the fuse box. CONRAD's bedside lamp goes out and the apartment is plunged into darkness. CONRAD screams.

CONRAD: Mother? Mother…?

MOTHER: Are you sure this is right?

DOCTOR: Of course I'm sure. Don't you trust me?

MOTHER: Well, yes…

DOCTOR: Quickly, the knife and fork.

Doubtfully, MOTHER picks up a carving knife and fork and walks up and down the hallway, banging the cutlery together.

CONRAD: Mother…help!

He rattles the door handle.

I can't get out…the door's locked…

DOCTOR: *(Smiling.)* Very good. I think we've done it.

He turns the lights back on. He places the jam and paintbrush in a cupboard. MOTHER walks to CONRAD's door, where she meets DOCTOR.

MOTHER: Now?

DOCTOR: Now.

MOTHER: *(Loudly but uncertainly.)* Did you hear that terrible noise?

DOCTOR: *(Loudly.)* It was more than terrible…

MOTHER: …it was *terrifying.*

CONRAD listens in silence.

DOCTOR: Whatever could have caused it?

MOTHER: The loud footsteps…

DOCTOR: …the clash of metal…

MOTHER: Do you think…?

DOCTOR: …the flash of fox-sharp teeth…

MOTHER: Could it be…?

DOCTOR: Without a doubt.

MOTHER *and* DOCTOR: Mister Holgado!

Beat.

DOCTOR: *(Loudly.)* I'll just make sure that Conrad is still asleep.

He smiles and unlocks the door, stepping into the room, followed by MOTHER. CONRAD is standing close to the door.

What are you doing there?

MOTHER: You should be asleep. You shouldn't be listening to us talking.

CONRAD: *(Terrified.)* I…I…I…I didn't hear anything.

DOCTOR: But you *have* heard something, haven't you?

CONRAD: Nothing. I thought I did…but I was wrong.

DOCTOR: You're not telling the truth.

Pause.

CONRAD: No.

DOCTOR: Well?

CONRAD: I heard noises.

MOTHER: Maybe you just imagined them?

CONRAD: Maybe there's something hiding? *Someone.*

Anxiously, he looks under the bed. DOCTOR takes the tiger growl box from beside CONRAD's bed, and hides it in his pocket.

DOCTOR: There's no one hiding under your bed.

CONRAD looks up, relieved.

It's the wardrobe you need to worry about.

MOTHER: *(Gently.)* You're scaring him.

DOCTOR: Of course I'm scaring him. There's a lot to be scared of.

CONRAD: What are you talking about?

DOCTOR: Sit down, Conrad.

CONRAD: Yes, Father.

DOCTOR: I think it's time you knew…

CONRAD: Knew what?

DOCTOR: There's no sense keeping it from you now.

To MOTHER.

Go on…

MOTHER: *(Anxiously.)* I don't want to.

DOCTOR: But you *have* to.

MOTHER: We thought about telling you before, Conrad, but it's always so hard trying to find the right time to…finding the right time to… I can't say it…

DOCTOR: Finding the right time to tell you that you're going to be eaten.

CONRAD: What?

DOCTOR: You used to say there were monsters under your bed. Of course, there weren't. You used to say there was

a bear watching you from the window, there wasn't. Now you say there's a man who hides in your wardrobe…

CONRAD: Yes?

DOCTOR: Unfortunately, there is.

MOTHER: Everything you've said about Mister Holgado –

DOCTOR: Everything is true.

MOTHER: We wish it wasn't, but it is.

Beat.

DOCTOR: There's something we have to show you.

They lead CONRAD into the kitchen. DOCTOR switches on the light, to illuminate 'Holgado' daubed on the wall. CONRAD is shocked.

It's still wet.

CONRAD: But he's gone now, I'm sure. He won't come back again.

DOCTOR holds up the battered doll and passes it to MOTHER, who moans again. They lead CONRAD back to his bedroom.

MOTHER: One day…I was all alone in the apartment. I heard noises coming from your bedroom… I thought perhaps it was coming from the apartment above. But it sounded so close. I opened the door… I thought I saw…a flash of… cutlery –

CONRAD: A knife and fork?

MOTHER: Yes…I saw a shadow moving…of a large man…a terrible man…the wardrobe door opened…the shadow seemed to move inside, then –

DOCTOR bangs the wardrobe door shut. CONRAD jumps.

The door slammed shut. No man, no noise. Silence. And there on the floor…the china doll…with one eye missing, and an arm ripped from the socket.

CONRAD: Where did it come from?

DOCTOR: There was a story in the newspaper. About a little girl…a little girl who'd disappeared. Nothing out of the ordinary, you might think. But you'd be wrong.

MOTHER: The little girl had been eaten.

DOCTOR: And what do you think her favourite toy was?

CONRAD: *(Petrified, his eyes closed.)* I don't know.

DOCTOR: I think you do.

MOTHER: A china doll…called Ingrid.

DOCTOR: *(Pointing, triumphantly.) That* china doll.

MOTHER: Mangled by Mister Holgado's ferocious teeth.

MOTHER hugs the doll tightly.

We would have returned the doll…but we thought it would make things harder for the little girl's parents.

DOCTOR: Better just to say nothing.

MOTHER: Of course, we tried speaking to the police, but there wasn't a thing they could do. It's much easier for them to pretend there's nothing going on.

DOCTOR: Less paperwork.

CONRAD: Is this true, Mother?

MOTHER: I wish it wasn't, but it is.

CONRAD: He eats the children?

MOTHER: Every last scrap. Like little bits of –

CONRAD: Meat?

MOTHER: Exactly.

Beat.

DOCTOR: And now it's time for you to go to sleep. Goodnight, Conrad.

MOTHER: Sleep well.

They close the door quietly.

DOCTOR: The plan is working.

MOTHER: *(Upset.)* He's terrified.

DOCTOR: By tomorrow morning he'll be begging to admit that there is no Mister Holgado.

MOTHER: *(Pointedly.)* You were the one who invented Mister Holgado.

DOCTOR: That's different. I'm the boy's father.

Beat.

Conrad is telling lies and he must be stopped.

MOTHER: But I'm supposed to kiss him better and say, 'darling, nobody's trying to kill you. It's just your imagination.'

DOCTOR: He has to learn.

MOTHER: I suppose you're right.

DOCTOR: I know I am.

MOTHER: But it does seem a shame.

They exit.

CONRAD sits in bed, the quilt pulled around him. Nervously, he points his torch at the wardrobe. Silence.

SCENE SIX

Morning. CONRAD wakes and sits up in bed. DOCTOR sits at the table, eating a breakfast of rye bread toast, strong black coffee and iced water. MOTHER makes more toast. They wait eagerly for CONRAD.

CONRAD: *(Entering.)* Good morning, Father.

DOCTOR: Good morning, Conrad.

CONRAD: Good morning, Mother.

MOTHER: I called you and called you. And when you didn't come I thought…well, it doesn't matter what I thought.

DOCTOR: Your mother thought that Mister Holgado had come in the night and eaten you.

MOTHER: Toast?

DOCTOR: He needs strong black coffee and a glass of iced tap water. Good for the brain.

He pretends to read the newspaper, watching CONRAD all the time.

Did you sleep well?

CONRAD: No.

DOCTOR: Did Mister Holgado come again?

Pause. CONRAD butters a slice of toast. MOTHER and DOCTOR wait expectantly.

CONRAD: Yes. Mister Holgado came.

DOCTOR: *(Frustrated.)* Did he speak to you?

CONRAD: Yes.

DOCTOR: And what did he say?

CONRAD: He said, 'I'm going to eat you up like a little bit of meat'.

DOCTOR: And he's quite right. That's exactly what he'll do.

Beat.

CONRAD: But I don't want to be eaten, Father.

DOCTOR: We all have to do things we don't want to do.

CONRAD pushes his plate away.

MOTHER: Aren't you hungry?

DOCTOR: Breakfast is the most important meal of the day. You need to build yourself up. Mister Holgado will be grateful for that.

He checks his pocket watch.

I shall be in my study.

He gets up from the table, kisses MOTHER on the cheek and walks to his study, closing the door behind him. He winds up his gramophone and plays a waltz. He paces the floor, perplexed.

CONRAD: May I get down from the table, Mother?

MOTHER: Very well.

She clears the table. CONRAD gets up from his chair and walks to the study door. He knocks.

DOCTOR: Come.

CONRAD enters.

Yes?

CONRAD: May I speak to you, Father?

DOCTOR fights to contain his excitement.

DOCTOR: Sit down.

CONRAD sits on the couch. DOCTOR lifts the needle off the gramophone.

Well?

CONRAD: Father…

He hesitates.

DOCTOR: Yes? Spit it out.

CONRAD: I want to talk to you about Mister Holgado.

DOCTOR: Ah ha.

> *Beat.*

> I shall call your mother.

> *Beat. He opens the door.*

> Darling!

> *MOTHER runs to the study.*

> Conrad wants to talk to us about Mister Holgado.

MOTHER: *(Delighted.)* You do?

CONRAD: Yes.

DOCTOR: What do you want to tell us?

CONRAD: Well…

DOCTOR: Go on.

CONRAD: Mister Holgado doesn't…

MOTHER: Doesn't what?

CONRAD: He doesn't…

DOCTOR: You can tell us.

CONRAD: Mister Holgado doesn't…

MOTHER: *(Desperately.)* He doesn't exist.

> *Beat. DOCTOR glares at her.*

> Does he?

> *Beat.*

CONRAD: Of *course* Mister Holgado exists.

> *DOCTOR beats his fist on the table. He composes himself and smiles at CONRAD.*

DOCTOR: Describe him.

Pause. CONRAD stares hard at the bust on DOCTOR's desk.

CONRAD: He's a very tall man.

DOCTOR begins to write in a notebook.

DOCTOR: As tall as me? Taller?

CONRAD: About as tall.

DOCTOR: Is he fat or thin? As thin as me?

CONRAD: About as thin.

MOTHER: It's strange that Mister Holgado is so thin, especially when he…

She mimes eating.

DOCTOR: Why don't you draw a picture of him?

MOTHER: What an excellent idea.

DOCTOR takes a large sheet of paper out of a drawer and places it on his desk. CONRAD sits and begins to draw. DOCTOR and MOTHER watch him anxiously.

CONRAD: I've finished the picture.

DOCTOR: Very good. Show us.

CONRAD: He looks like this.

He holds up the drawing. MOTHER recoils in horror.

DOCTOR: So, this is Mister Holgado?

CONRAD: Yes.

DOCTOR: Just as I thought. Every bit as terrifying as I imagined.

CONRAD: He let Sigmund out because he's scared of tigers. His mother and father were eaten by a tiger.

DOCTOR pins the picture to the wall.

DOCTOR: Doesn't everybody know that?

CONRAD: He's got bad teeth.

DOCTOR: Probably from eating so many children.

CONRAD: He doesn't like anchovy and herring paste.

DOCTOR: No?

CONRAD: He smells of cough syrup and peppermints.

DOCTOR: He likes sweet things?

CONRAD: It's so people don't smell the children he's eaten.

DOCTOR: Yes, very sensible.

CONRAD: He's a very sensible man.

MOTHER: I think I might like Mister Holgado.

> CONRAD stares at MOTHER.

No…of course I wouldn't like him. I don't know what I was thinking.

DOCTOR: How does Mister Holgado make a living?

CONRAD: Mister Holgado sells eyes.

MOTHER: Eyes?

DOCTOR: Exactly.

CONRAD: Glass eyes.

DOCTOR: I see. And where does he live?

CONRAD: A long way away. Hundreds of kilometres.

DOCTOR: In an apartment like this?

CONRAD: In a house…on a hill. He has a special room where he goes to sharpen his knife and fork.

DOCTOR: What does the room look like?

CONRAD: It's decorated with photographs of all the children he's eaten…and he keeps all their toys in a big box.

DOCTOR: Does he eat every child he finds, or does he prefer some children more than others?

CONRAD: He only eats the clever children.

DOCTOR: I see.

CONRAD: Do you?

DOCTOR: I beg your pardon.

CONRAD: You understand?

DOCTOR: I understand perfectly.

CONRAD: He comes on the train.

DOCTOR: Of course he does. A very sensible way to travel.

CONRAD: He plays music. Loud music.

DOCTOR: Why?

MOTHER: If he likes music he can't be all that bad.

CONRAD: But he doesn't like music.

MOTHER: Then why does he listen to it?

DOCTOR: He plays it so nobody can hear him eating the children.

MOTHER: Is he a noisy eater…?

DOCTOR: What sort of music does he play?

CONRAD: Old records.

MOTHER: …because it's very rude to eat noisily…

DOCTOR: What records?

CONRAD: Like fairground music.

MOTHER: …I thought he'd have better manners.

Suddenly.

Will there be much blood?

DOCTOR: It's difficult to say. It depends.

CONRAD: On what?

DOCTOR: On how much blood he's got in him.

MOTHER: Quickly, the paper bag.

DOCTOR passes MOTHER a paper bag.

DOCTOR: Breathe in…and out…

MOTHER does so.

MOTHER: *(Tearfully.)* Remember, Conrad, that we love you. When that awful day comes…when Mister Holgado climbs out of your wardrobe with his knife and fork…

She holds out her arms to CONRAD.

DOCTOR: I think it's important that we don't become too attached to the boy.

Awkwardly, MOTHER pats CONRAD on the head and runs sobbing into the hallway.

Now see what you've done.

Beat.

You're a very selfish little boy. You don't want to be eaten, of course you don't. Nobody wants to be eaten. But I've got your mother to think of as well. This isn't just about you, Conrad. You understand?

CONRAD: Yes, Father.

DOCTOR checks his pocket watch.

DOCTOR: Your appointment has ended. Good morning.

CONRAD exits.

Close the door.

CONRAD closes the door behind him and walks into his bedroom. He stands silently, staring at the wardrobe. MOTHER knocks quietly on the study door.

Come.

MOTHER enters.

Close the door.

MOTHER: Well?

DOCTOR: Well? Well what?

MOTHER: I thought you said your plan would work. I thought
you said Conrad would admit that Mister Holgado did not
exist.

DOCTOR: That's what I said, yes.

MOTHER: But he didn't.

DOCTOR: No.

MOTHER: He said that Mister Holgado does exist.

DOCTOR: I know what he said.

MOTHER: So you were wrong, weren't you?

DOCTOR: Yes.

MOTHER: *(Cheerfully.)* Entirely wrong.

DOCTOR: Conrad is more clever than I thought.

MOTHER: Is that a good thing?

DOCTOR: Of course not.

The cuckoo clock strikes nine.

Nine o'clock.

*DOCTOR puts on his hat and coat, and picks up his umbrella and
attaché case. MOTHER follows him into the kitchen.*

MOTHER: But what about Conrad? What do we do now?

DOCTOR: Now…?

Beat. He opens the front door.

Now I must become Mister Holgado.

He exits.

SCENE SEVEN

MOTHER waits anxiously in the kitchen. CONRAD sits in his bedroom, studying his books. There is a gentle tapping at the front door. MOTHER opens the door and DOCTOR peers cautiously into the kitchen, flustered but excited.

DOCTOR: Is he studying his books?

MOTHER: He is.

> *DOCTOR carries in a wooden box, which he places on the kitchen table. The box is decorated with a large painted eye.*

Where did you find it?

DOCTOR: In an antique shop in the Old Town.

> *MOTHER reaches out her hand to touch the box.*

Don't touch it!

> *He checks his pocket watch.*

We only have a few minutes.

MOTHER: What can I do?

DOCTOR: Make sure that Conrad remains in his bedroom.

> *He exits through the offstage hallway. MOTHER silently locks CONRAD's door. DOCTOR rushes back into the kitchen with two suitcases. He hurries into the study, followed by MOTHER.*

> *Excitedly, he rubs his hands together. He takes a small box out of his jacket pocket.*

MOTHER: What is that?

DOCTOR: It's a moustache.

MOTHER: A moustache?

DOCTOR: A false moustache.

MOTHER: But why?

DOCTOR: I found a shop in a street off Edvardplatz…a shop selling wigs and moustaches. 'Alter your appearance overnight with Duttlinger's patented artificial hair.'

He takes out a bottle of gum and sticks the moustache to his upper lip.

What do you think?

MOTHER: Horrible.

DOCTOR looks in the mirror, admiring the moustache. He takes out another box, containing a set of sharp fox-like teeth which he tries on. He smiles at MOTHER, revealing the pointed teeth. MOTHER squeals, delighted.

DOCTOR: Do I look like Mister Holgado?

He stands next to CONRAD's picture of Mister Holgado. MOTHER compares the two.

MOTHER: Every bit.

DOCTOR flicks open the notebook on the desk.

DOCTOR: *(Reading.)* 'He smells of cough syrup and peppermints…'

MOTHER: I have a bag of peppermint lozenges.

She takes out a bag of peppermints and offers it to DOCTOR. He takes a peppermint and eats it, then takes the bag as well.

DOCTOR: Good. Very good.

He hurries into the kitchen, and opens a cupboard door.

Cough syrup…cough syrup…cough syrup…cough syrup…

He finds a bottle of cough syrup, takes a mouthful, swills it round his mouth, and spits it into the sink.

Disgusting.

He picks up the two suitcases and checks his pocket watch again.

Thirty seconds before the whistle.

Beat.

I will run downstairs to the telephone kiosk…you know what to do?

MOTHER: Yes.

DOCTOR: As soon as I go to my room as Holgado I will lock the door and climb out through the window. I will make my way down the fire escape and return through the front door as myself. Doctor Van der Bosch.

MOTHER: Yes. Yes, of course.

DOCTOR kisses MOTHER on the cheek.

Good luck.

DOCTOR: This is not about luck. It is about a scientific approach to…

He checks his watch.

It doesn't matter. You wouldn't understand.

He exits.

MOTHER: I might.

She reaches out her hand to touch the box. Beat. DOCTOR opens the door again.

DOCTOR: Don't touch!

He exits, closing the door quietly behind him. Pause. The factory whistle screams out. CONRAD closes his books, he tries to open the door, but it is locked. He rattles the handle.

CONRAD: Mother?

MOTHER quietly unlocks the door and enters CONRAD's bedroom.

MOTHER: Did you call, darling?

CONRAD: The door was locked…again.

MOTHER: *(Awkwardly.)* It wasn't locked…why would I lock the door? It must be your imagination.

CONRAD walks into the kitchen, MOTHER follows.

CONRAD: Where is Father?

MOTHER laughs nervously.

MOTHER: I don't know. It isn't like your Father to be late. He's always so punctual.

Beat.

Maybe he's been run over on the tram lines...that's often happening...the number of people who slip on the rails and have their heads sliced from their shoulders by the wheels of the tram...we need to face the possibility that something horrific has happened to your father...why else would he be late?

CONRAD stares at the box on the kitchen table.

CONRAD: Where did the box come from?

MOTHER: The box? I don't know. I heard the buzzer...I opened the door...and there was the box. No delivery boy. No note of explanation.

CONRAD reaches out to touch the box.

Don't touch!

The telephone rings, MOTHER pounces at it.

Good evening, this is Mrs Van der Bosch in apartment 19C, Marshal Podovsky Street...

CONRAD: Who is it?

MOTHER: It's your father. Yes...yes...he said he decided to visit the zoo. He met a very interesting man there...a tall man with sharp little teeth. A very polite man... He says he likes children... He asked all sorts of questions about you, Conrad... He's in town on business...yes, yes... He needed a place to stay...your father said he'd be very welcome to come and stay here...a very sensible idea. It will be company for little Conrad. Yes, goodbye, darling.

She hangs up.

Your father says he is just going to finish feeding the penguins, and then he will come home.

CONRAD: *(Nervously.)* The man…with sharp little teeth…he's coming to stay here?

MOTHER: That's what your father said.

CONRAD: But what's the man's name?

MOTHER: I don't remember.

CONRAD: Is it Mister Holgado?

MOTHER: I told you, I don't remember. I can't be expected to remember the name of every strange man your father invites to stay in our apartment.

The door buzzer sounds loudly. MOTHER yelps.

Who can that be? I wasn't expecting visitors. Why don't you answer it?

CONRAD: Me?

The buzzer sounds again. CONRAD opens the door. DOCTOR stands outside, dressed as HOLGADO. He looks identical to CONRAD's drawing. He carries two suitcases.

HOLGADO: Good evening.

MOTHER: Can we help you?

CONRAD stands frozen to the spot. HOLGADO takes a dirty scrap of paper from his pocket.

HOLGADO: Is this apartment 19C…Marshal Podovsky Street?

MOTHER: It is.

HOLGADO: The apartment of Doctor and Mrs Van der Bosch…

He bends down to face CONRAD.

…and little Conrad?

MOTHER: Yes.

HOLGADO: I've come about the room.

MOTHER: What room?

HOLGADO: The room you're letting out.

MOTHER: Of course. But…

HOLGADO: Yes?

MOTHER: I don't like to be rude…but there are so many bad and dangerous people out there, how can I be sure that you're the same man my husband spoke to about the room?

HOLGADO: Very sensible. I could be anybody couldn't I? I could be here to burgle your house…or eat your little boy. I could be anybody.

MOTHER: I'm sorry?

HOLGADO: I said…very sensible.

CONRAD: *(Anxiously.)* Mother –

HOLGADO: Look at me…do I look like a bad and dangerous man?

He smiles, revealing his fox-sharp teeth. He licks his lips, attempting to look charming.

MOTHER: No, of course not. Please come in.

HOLGADO: Thank you.

Beat. He takes something out of his pocket – it seems to be moving. He eats it, as CONRAD watches. MOTHER does not notice. HOLGADO reaches into his pocket and holds out his hand.

Want a cockroach?

CONRAD backs away.

MOTHER: You didn't tell me your name.

HOLGADO: No, I didn't.

MOTHER: Well?

HOLGADO: My name is…

MOTHER: Yes?

HOLGADO: My name is Mister…

MOTHER: Yes, go on.

HOLGADO: My name is Mister…

Beat.

CONRAD: Holgado?

HOLGADO: My name is Zankovitch. Mister Zankovitch.

CONRAD: But, Mother…this is Mister Holgado.

HOLGADO: The boy's got wax in his ears. My name is Zankovitch. Z…A… Zankovitch.

He breathes on CONRAD.

CONRAD: Peppermints and cough syrup!

MOTHER: And you're in town on business?

HOLGADO: You could say that.

MOTHER: Will you be staying here long?

HOLGADO shoots a glance at CONRAD.

HOLGADO: As long as it takes.

Beat.

Now, about the room…

CONRAD runs into the study and takes down the picture of HOLGADO.

MOTHER: *(Whispered.)* How horrible. If I didn't know it was you, I would think you really *were* Mister Holgado.

DOCTOR: Do you think…

He has trouble with the false teeth, and removes the upper set.

…do you think Conrad suspects that it's only me…in disguise?

MOTHER: Why would he suspect anything?

CONRAD returns with the drawing. DOCTOR hastily puts in his false teeth. As HOLGADO, he stares at the writing daubed on the kitchen wall.

HOLGADO: No wonder the boy was worried that I might be Mister Holgado.

MOTHER: So…you have heard of Mister Holgado?

HOLGADO: Of course. Hasn't everybody?

Beat.

Looking for Conrad, is he?

MOTHER: He is.

HOLGADO: That's a bad sign. Very bad.

CONRAD: How do you know my name?

HOLGADO: I know all sorts of things.

Beat.

About the room…

MOTHER: Yes, of course. I'm afraid it's rather small.

HOLGADO: No matter.

MOTHER: Did you come by motorcar?

HOLGADO: I came by train.

MOTHER: Do you have any more suitcases?

HOLGADO: Just these two.

He looks at the box on the table.

And I see my box has arrived.

CONRAD: It's your box?

MOTHER: Conrad will take a case for you.

CONRAD reaches out his hand to touch the box.

HOLGADO: No! Not that one!

Beat.

I'm sorry. I didn't mean to startle the boy.

He rubs CONRAD's head, too hard. CONRAD winces.

A lovely little man, aren't you? I do like kill-dren...all sorts, boys and girls. All sorts of little kill-dren.

MOTHER: If you will follow me, Mr Zankovitch.

HOLGADO: Don't have any rats here, do you?

MOTHER: Rats? Of course not.

She exits.

HOLGADO: Pity.

He seems to notice a cockroach running round his feet; he stamps on it, picks it up and crunches it down. He follows MOTHER off. CONRAD makes sure no one is coming and is about to open a drawer in the side of HOLGADO's box when MOTHER returns.

MOTHER: Isn't Mister Zankovitch a nice man?

CONRAD: No. He's not a nice man. He's come to eat me. And his name isn't Mister Zankovitch...it's Mister Holgado.

MOTHER: But you heard what he said...his name is Zankovitch. He said it quite distinctly.

CONRAD: Maybe he's not telling the truth.

MOTHER: Why would he lie?

CONRAD: People don't always tell the truth.

Beat.

Look.

He holds up the picture of HOLGADO.

MOTHER: But that doesn't look like Mr Zankovitch. Not at all. The eyes and the nose…all different.

CONRAD: But, Mother…

HOLGADO returns, smiling. He stares at the box.

HOLGADO: You didn't open the box?

CONRAD: No.

HOLGADO: You're sure?

CONRAD: No. Yes. I mean…no, I didn't open it.

HOLGADO: 'Cause I'll know. I'll know if you've opened it.

CONRAD backs away.

I always know.

He is about to open the box when the lights begin to flicker and crackle.

MOTHER: Don't be alarmed. I am afraid we have trouble with the electrics.

HOLGADO: That's rats, that is…gnawing through the wires. Rats. Fat…grey…juicy…

MOTHER does not hear.

MOTHER: Have you eaten?

HOLGADO stares at CONRAD.

HOLGADO: Not yet.

MOTHER: My husband tells me you like penguins.

HOLGADO: Delicious…broiled or roasted…or just fried up in black butter?

MOTHER: I meant…at the zoo.

HOLGADO: Oh, yes. Wonderful birds, penguins.

MOTHER: Is it true they can't fly?

HOLGADO: Very true.

MOTHER: How sad.

HOLGADO: Makes them easier to catch.

MOTHER: My husband, the Doctor, said you met at the zoo.

HOLGADO: Quite right. He didn't tell no word of a lie. I was looking at the penguins, then your husband arrived and I noticed that he was looking at the penguins. Then we started talking…about how we both liked penguins.

MOTHER: There are so many things I don't seem to know about my husband.

HOLGADO: Did you know there are seventeen species of penguin?

MOTHER: No.

HOLGADO: Did you know that lions eat penguins?

CONRAD: No they don't.

HOLGADO: They do. I was at the zoo, and a penguin ended up in the lion's cage. It ate him all up, beak and feathers… even his little webbed feet. So there.

MOTHER: I don't know what you would like to eat?

HOLGADO: I'll have a sandwich, please. In my room. Perhaps Conrad will bring it?

MOTHER: Would you like smoked ham…or boiled beef…or anchovy and herring paste…?

HOLGADO steps back in alarm.

HOLGADO: Not anchovy and herring paste…*never* anchovy and herring paste.

Beat.

It doesn't agree with me.

He laughs, nervously. He takes another cockroach out of his pocket and eats it.

MOTHER: Sardines?

HOLGADO: I've gone off sandwiches now. I think I'll just go to my room.

MOTHER: Of course. You must have had a long journey.

HOLGADO: All the way from my house on the hill.

He smiles at CONRAD. CONRAD sticks his tongue out.

You're a nice little boy, aren't you?

MOTHER: We're quite pleased with him.

HOLGADO: It's a pity I'm going to have to eat you.

MOTHER: Did you say something?

HOLGADO: I said it's a beautiful apartment. Very comfortable.

MOTHER: Thank you.

HOLGADO: *(Quietly, to CONRAD.)* Bones and all.

He exits.

CONRAD: He is Mister Holgado. He came here by train…he lives in a house on a hill…he smells of peppermints and cough syrup…

Beat.

…and he doesn't like anchovy and herring paste.

MOTHER: A lot of people don't like anchovy and herring paste.

Loud fairground music is heard from HOLGADO's room.

CONRAD: He listens to fairground music!

MOTHER looks at the clock.

MOTHER: Your father is very late.

Beat. On cue, the key is heard in the door and DOCTOR enters – still wearing HOLGADO's moustache.

DOCTOR: Good evening my dear, good evening Conrad.

He kisses MOTHER on the cheek.

MOTHER: Did you have a good day?

Before CONRAD can see, MOTHER rips off the moustache. DOCTOR winces.

DOCTOR: An excellent day.

MOTHER: You're very late.

DOCTOR: I fed the penguins. When I looked at my pocket watch, it was much later than I imagined.

MOTHER: I see.

DOCTOR: A perfectly satisfactory explanation.

MOTHER: Yes.

DOCTOR: Do you have any further questions?

MOTHER: No.

DOCTOR: Very good then.

MOTHER: I imagined you'd been run over on the tramlines… or murdered in a dark alley.

DOCTOR: As you can see, I am quite well.

MOTHER: *(Disappointed.)* Yes. Yes, of course.

DOCTOR: Has Mister Zankovitch arrived?

MOTHER: Yes. He's in his room.

DOCTOR calls, off.

DOCTOR: Good evening, Mister Zankovitch.

No answer.

MOTHER: He must be asleep. He's had a long journey, from his house on the hill.

DOCTOR: Do you agree with me, that he is a very nice man?

MOTHER: Oh, yes.

CONRAD: You met him at the zoo?

DOCTOR: That is correct. We had a shared interest in penguins.

CONRAD: You never said that you liked penguins.

DOCTOR: You never asked me.

CONRAD: When did you *start* liking penguins?

DOCTOR: Little boys shouldn't ask too many questions.

MOTHER holds out the picture of HOLGADO.

MOTHER: Conrad thinks that Mister Zankovitch is really Mister Holgado…in disguise.

DOCTOR: That is a very rude thing to say about our guest. To suggest that kind Mister Zankovitch, who likes penguins, is really here to eat you. If I thought for one minute that Mister Zankovitch ate children, do you really think I would have invited him into our apartment to stay with us?

CONRAD looks doubtful.

Well?

CONRAD: No, Father.

DOCTOR: Quite right. You will know for a fact when Mister Holgado arrives…the tell-tale signs: the fox-sharp teeth, the sharpening of his knife and fork…

MOTHER: Quickly, wash your hands for supper.

CONRAD heads towards the offstage hallway. DOCTOR picks up a knife and fork, and sharpens them sinisterly. CONRAD turns,

petrified. DOCTOR smiles sweetly. MOTHER takes a jar from a cupboard.

DOCTOR: Anchovy and herring paste. Excellent.

The fairground music continues to play, increasing in volume and reverberating around the apartment with a sinister echo.

Act Two

SCENE ONE

MOTHER stands in front of the hall mirror, putting on lipstick. CONRAD is studying in his bedroom. The factory whistle shrieks. CONRAD puts down his books and enters the hall.

CONRAD: What are you doing?

MOTHER: I'm trying to look nice for Mister Zankovitch.

> *The door buzzer sounds.*

> That must be him now.

> *She opens the door.*

> Good evening, Mister Zankovitch.

> *HOLGADO enters, carrying the eye box.*

HOLGADO: Good evening Mrs Van der Bosch…good evening little Conrad.

> *He places the box on the kitchen table. He opens a flap in the side of the box and pulls out a bunch of long-stemmed white lilies. He bows and presents the flowers to MOTHER.*

MOTHER: What beautiful flowers.

> *HOLGADO takes out a box of chocolates, wrapped with a large red bow, which he passes to MOTHER.*

> For me?

> *HOLGADO nods. MOTHER unties the bow and lifts the lid of the box.*

> Champagne truffles?

HOLGADO: The very best.

> *MOTHER smiles and takes a bite of one of the chocolates.*

MOTHER: A crisp chocolate shell.

HOLGADO: Of course.

MOTHER: Fresh cream?

HOLGADO: Naturally.

MOTHER: Delicious.

> *She eats the chocolate. HOLGADO watches her closely. She giggles.*

You brought me chocolates. How wonderful. How did you know? Look, Conrad. Champagne truffles. I love champagne truffles.

HOLGADO: I thought you might.

> *He takes out another box, wrapped with a black bow.*

For the little boy.

> *CONRAD opens the lid a crack and reaches into the box – HOLGADO snaps the lid shut on CONRAD's hand. CONRAD flinches, HOLGADO smiles.*

Go on…take one.

> *CONRAD takes a chocolate and chews.*

CONRAD: It tastes of cough syrup.

HOLGADO: Eat it all down like a good little boy.

> *With difficulty, CONRAD swallows the chocolate.*

It's nice to see a child with a healthy appetite.

MOTHER: Conrad enjoys his food, don't you, Conrad?

HOLGADO: Too many thin little boys and girls running round, almost with the bones showing through. I prefer kill-dren with a bit more meat on them…if you know what I mean? Healthy looking kill-dren, I mean.

MOTHER: I'm so pleased that you like children, Mister Zankovitch.

HOLGADO: Oh yes, I like them very much.

CONRAD watches in horror as HOLGADO licks his lips, unseen by MOTHER.

MOTHER: I always hoped that Conrad would have a friend, and now he has.

HOLGADO: How heavy is he?

MOTHER: How heavy?

CONRAD: Don't tell him.

MOTHER: Conrad can be a very rude little boy sometimes.

HOLGADO takes a tape measure out of his pocket and measures CONRAD.

CONRAD: What are you doing?

HOLGADO: Working things out.

CONRAD: What things?

HOLGADO: Nothing to worry your head about.

He makes notes in a pocket book.

MOTHER: What do you do, Mister Zankovitch?

HOLGADO: Do?

MOTHER: For a job. What do you do?

Beat.

HOLGADO: Eyes.

MOTHER: Eyes?

HOLGADO: Glass eyes mostly. It's surprising the number of people whose eyes stop working or drop out.

MOTHER: Drop – ?

HOLGADO: Out. Just drop out of their heads.

MOTHER: Does that happen very often?

HOLGADO: More often than you might think.

> *He presses a button on the side of the box – a large, glowing eyeball rises from inside. MOTHER is shocked, she laughs uncomfortably.*

Blue eyes, green eyes, brown, grey…

> *He opens a door in the box. It is crammed full of glass eyes.*

Here…try one for size.

> *He throws a glass eye to MOTHER, which she catches.*

You see? Every shape and colour under the sun.

> *With a sleight of hand, HOLGADO magically produces a glass eyeball from behind CONRAD's ear. CONRAD gasps.*

MOTHER: How clever!

HOLGADO: You want another chocolate?

CONRAD: No.

MOTHER: No thank you, Mister Zankovitch.

CONRAD: *(Sarcastically.)* No thank you, Mister Holgado.

MOTHER: I can't think whatever's got into him.

HOLGADO: I know what kill-dren like…all little kill-dren…

> *Beat.*

Toys!

> *He opens the box, which springs into life. It is illuminated from within and full of brightly painted toys.*

MOTHER: Look, Conrad…look at all the toys. Mister Zankovitch must like children very much.

HOLGADO: And what toy would little Conrad like?

CONRAD: I want the spinning top.

HOLGADO: Little Conrad shall have the clockwork monkey.

He picks up a clockwork monkey with cymbals and winds the key. MOTHER puts the lilies in a vase.

CONRAD: Where did all the toys come from?

HOLGADO: Ask me no questions, and I'll tell you no lies.

He smiles, sinisterly, and passes the monkey to CONRAD. The cymbals clatter noisily.

MOTHER: Say thank you to Mister Zankovitch, Conrad.

CONRAD: Thank you.

HOLGADO: Do you like music?

MOTHER: Yes.

HOLGADO opens a drawer in the box, and removes a portable gramophone. He winds it up, and places the needle on the disc. Loud fairground music begins to play.

HOLGADO holds out his hand to MOTHER. Together, they waltz around the kitchen.

CONRAD places the monkey on the floor. He looks at his hand – it is red. He hurries to his bedroom and takes a magnifying glass from the bedside table.

The gramophone hisses and crackles.

MOTHER: Maybe you should use a new gramophone needle?

HOLGADO: I like them to grind blunt. It makes the music more…scratchy.

The record jumps…

…scratchy…scratchy…

…and MOTHER and HOLGADO are stuck in the same dance step. Calmly, HOLGADO walks to the table. He bashes the gramophone, and the music resumes. He holds out his hand to MOTHER and they continue to waltz.

CONRAD returns and picks up the monkey, observing it closely under the magnifying glass.

CONRAD: There's blood on it.

The gramophone record ends, only the crackle of the revolving disc can be heard.

MOTHER: Blood?

HOLGADO: Blood? No blood.

He picks up the monkey.

I'll clean it up…

He takes a napkin from his pocket – a knife and fork clatter to the floor. CONRAD bends down and picks up the fallen cutlery.

CONRAD: *(Suspiciously.)* A knife…and a fork?

HOLGADO snatches back the cutlery.

HOLGADO: Mine!

He wraps the knife and fork in the napkin and returns them to his pocket.

No more toys…not for bad little boys that deserves everything what's coming to them.

He closes the eye box.

Goodnight.

Beat. He smiles strangely.

Sleep well.

He exits, taking the box with him.

MOTHER: How surprising.

CONRAD: Mother…he had a knife and fork…

MOTHER: I know. I do have eyes in my head. Just because Mister Zankovitch carries a knife and fork in his pocket, it doesn't mean that he eats children.

CONRAD: Mother…there was blood on the napkin.

MOTHER turns, horrified. Offstage, the fairground music plays from HOLGADO's room.

SCENE TWO

CONRAD sits alone at the kitchen table eating his breakfast. DOCTOR rushes into the kitchen from the offstage hallway, straightening his tie. His hair is sticking up and he attempts to comb it into place with his fingers.

DOCTOR: What time is it?

CONRAD: Half past eight, Father.

DOCTOR: I'm late. Terribly late. Why didn't you call me?

MOTHER: *(Entering.)* What about breakfast?

DOCTOR: I have no time.

MOTHER: But, darling –

DOCTOR: At nine o'clock I have to see a little girl who chews each mouthful of food a hundred and fifty times before she swallows it, at ten o'clock I have an appointment with a boy who thinks he is being hunted down by wolves, at eleven o'clock I have to visit a little boy who believes he is turning into a cockroach. I have no time for breakfast.

He stalks into the study, followed by MOTHER. She closes the door. CONRAD runs to listen at the keyhole.

MOTHER: *(Quietly.)* First you are Mister Holgado, then you are Doctor Van der Bosch, then you are Mister Holgado, then you are Doctor Van der Bosch again. It's very confusing. It's no wonder you overslept.

DOCTOR: I overslept because you forgot to wake me.

MOTHER: I forgot to wake you because you forgot to set the alarm clock.

DOCTOR: Where is my case? I've lost my case.

MOTHER: Do you remember where you put it?

DOCTOR: If I remembered where I'd put it, it wouldn't be lost, would it?

He hunts for his case.

MOTHER: Mister Holgado is much nicer than you are.

DOCTOR: I beg your pardon?

MOTHER: Mister Holgado is a very charming man. He spends much more time with Conrad than you do.

DOCTOR: But Mister Holgado is going to eat Conrad.

MOTHER: Mister Holgado brought me flowers and champagne truffles. I can't remember the last time you brought me flowers or chocolates. Mister Holgado is a very good man.

DOCTOR: Mister Holgado is a bad man because he eats children, I am a good man because I do not.

Beat.

Have you been taking your pills?

MOTHER: I don't want any more pills. I want Mister Holgado.

DOCTOR: *(Angrily.)* There is no Mister Holgado. I am Mister Holgado.

CONRAD staggers backwards in disbelief – he lets out a loud gasp.

MOTHER: What was that?

DOCTOR: What was what?

MOTHER: I thought I heard something.

DOCTOR: Hallucinating? A very bad sign.

He continues to search for his case.

MOTHER: I think it's unhealthy, telling Conrad he's going to be consumed by a strange man who hides in wardrobes.

DOCTOR: Ridiculous.

MOTHER: I think it will make him very unwell.

DOCTOR: We're trying to make him better. We're helping him.

MOTHER: How is it helping him if we tell him that he's going to be eaten up like a little piece of meat? I think you went too far…covering the toys in blood.

DOCTOR: It was sour cherry jam.

MOTHER: It looked like blood.

DOCTOR: It is important that we get the details right.

MOTHER: We're terrible, terrible people.

DOCTOR: We're good people.

MOTHER: Do you think Conrad likes us?

DOCTOR: Of course he likes us. We're excellent parents.

MOTHER: Are we?

DOCTOR: Of course we are. Would we be doing this if we weren't good parents?

MOTHER: But can't you tell Conrad that he's not going to be eaten up…not *really*.

DOCTOR: Not until he admits that he's been telling lies.

MOTHER: But *you* dreamed up Mister Holgado. You told that lie.

DOCTOR: Only to help the boy. And as soon as Conrad admits that Mister Holgado does not really exist, then everything can return to normal. But whatever happens Conrad cannot…must not win.

MOTHER: If you don't tell Conrad that he isn't really going to be eaten, then I will.

DOCTOR: You're trying to turn him against me.

MOTHER: I am?

DOCTOR: Don't deny it.

He advances on MOTHER. She backs away nervously.

MOTHER: I don't know what to say.

DOCTOR: Just tell me the truth.

MOTHER: I don't know what's true and what isn't…you're getting me confused.

Beat.

DOCTOR: Why does Conrad like you more than me?

MOTHER: Because I'm nicer than you are.

DOCTOR: No you're not.

MOTHER: I think you scare Conrad.

DOCTOR: You think that he's scared of me? Of his own father?

MOTHER: I'm scared of you.

Beat.

Conrad has bad dreams.

DOCTOR: We all have bad dreams. It's a perfectly natural state of affairs.

MOTHER: I had a dream…a wonderful dream. We were standing on a cliff, and I saw a beautiful bird, a fabulous golden eagle…it was soaring in the sky, high above us. And I said, 'Darling, look at the beautiful eagle'. But you weren't listening…you were saying how untidy everything was, and how important it was for children to understand long division and algebra by the age of seven…and then the golden eagle swooped down and bit your head off.

DOCTOR: That was your wonderful dream?

MOTHER: Yes. And then I woke up, and there you were with your head still on. Which was rather disappointing.

DOCTOR turns his back on MOTHER.

You're just upset with Conrad because he is more intelligent than you are.

DOCTOR: Why did you say that?

MOTHER: I said it because it's true.

DOCTOR: I am cleverer than him. I'm much cleverer. Ask me any question, I'll tell you the answer. The square root of twelve million…how many species of beetle exist in the world…

He picks up the beetle box and examines it closely.

…Megasoma elephas…

MOTHER: I beg your pardon?

DOCTOR: My new beetle.

MOTHER: What about it?

DOCTOR: It's gone.

Beat.

It's escaped…

MOTHER arms herself with the tribal bust and stands on the chair behind the desk.

Where can it be…?

MOTHER: Find it…

DOCTOR gets down on his hands and knees.

Kill it…kill it!

DOCTOR: Ah…here it is.

He darts out from behind the desk, beetle-like. At the same moment MOTHER shrieks and hurls the bust at the floor, but misses and catches DOCTOR on the head. He screams out in pain. CONRAD flings the door open, angrily.

CONRAD: What are you doing to Mother?

MOTHER: Conrad!

DOCTOR staggers to his feet, dazed. He clutches his attaché case to his chest.

Darling…are you hurt?

The side of DOCTOR's head is covered in blood. MOTHER whispers.

Sour cherry jam?

She reaches out her hand to touch the blood. She tastes it, horrified.

Blood!

DOCTOR walks out of the study.

Darling?

CONRAD: I want to talk to you, Mother.

MOTHER: Not now, Conrad.

MOTHER follows DOCTOR into the kitchen and CONRAD follows behind. DOCTOR puts on his hat and picks up his umbrella.

DOCTOR: Goodbye.

MOTHER: But, darling –

DOCTOR exits through the offstage hallway. MOTHER stares anxiously at CONRAD. Beat. DOCTOR returns, unfazed. He opens the apartment door. He opens the umbrella, but it is too wide to get through the door.

CONRAD: Is he ill, Mother?

MOTHER: I think he might be.

DOCTOR closes the umbrella and is able to pass through the door.

DOCTOR: *(Smiling oddly.)* Goodbye.

He exits. CONRAD and MOTHER exchange anxious glances.

SCENE THREE

That evening. MOTHER stands anxiously in the kitchen. CONRAD paces his room, deep in thought.

The factory whistle sounds. CONRAD enters the kitchen.

Pause.

The door buzzer sounds loudly.

CONRAD: Who is it?

MOTHER: I don't know.

> *Beat.*

> Will you answer it, Conrad? Please?

> *CONRAD opens the door.*

> Well?

CONRAD: There's nobody there…

> *Suddenly HOLGADO looms into view, looking grubbier than before. His head is wrapped in a bloodied bandage. He raises his hat as he staggers into the kitchen. He is even more Holgado-like than ever.*

HOLGADO: Good evening.

MOTHER: *(Shocked.)* Darling!

> *CONRAD stares at MOTHER. She collects herself.*

> …Darling Mister Zankovitch…

HOLGADO: Good evening.

> *He raises his hat again and steadies himself against a kitchen cupboard.*

CONRAD: Is he drunk, Mother?

MOTHER: You look a little different, Mister Zankovitch.

HOLGADO: I hit my head…nothing to concern yourselves with…just a…I hit my head, did I tell you that?

CONRAD: Yes.

HOLGADO: *(Menacing.)* Then I won't tell you again.

Pause.

Good evening.

He raises his hat again.

MOTHER: *(Concerned.)* Conrad…run and fetch your books. Show Mister Zankovitch all the clever work you've been doing.

CONRAD: But, Mother…

HOLGADO slumps.

MOTHER: Quickly, Conrad, before Mister Zankovitch falls over.

Reluctantly, CONRAD runs off to his bedroom.

HOLGADO: I hit my head.

MOTHER: Are you quite all right?

HOLGADO: I don't remember…

MOTHER: Who bandaged your head for you?

HOLGADO: I was at the zoo…by the penguin pool…a zookeeper done it.

MOTHER: 'Done it'? You mean…did it.

HOLGADO: And that's what I said.

He reaches into his pocket.

Cockroach?

MOTHER shrieks. CONRAD returns from his bedroom carrying a mathematics book. MOTHER takes CONRAD by the arm and leads him into the hallway. HOLGADO listens in on their conversation.

MOTHER: Conrad, Mr Zankovitch has had an…an accident.

CONRAD: *(Suspiciously.)* What sort of an accident?

MOTHER: He hit his head very hard and it has made him rather…strange.

CONRAD: I told you he was strange.

MOTHER: We must be very careful not to upset him. I'm sure he'll be quite better in the morning.

She exits to the kitchen – HOLGADO picks up the telephone and talks loudly.

HOLGADO: Good evening, Doctor Van der Bosch.

MOTHER: Doctor Van der Bosch? I didn't hear the telephone ring.

HOLGADO: He says he won't be home tonight.

MOTHER: Why not?

HOLGADO: He wants me to look after you…you and your sweet little angel, Conrad.

MOTHER: I would like to speak to my husband.

HOLGADO: You can't.

MOTHER: Why not?

HOLGADO: *(Into telephone.)* Thank you, honoured Doctor.

MOTHER: *(Insistently.)* May I please speak to my husband?

HOLGADO: No. He's gone.

MOTHER: Gone where?

HOLGADO: Just gone.

MOTHER: How do you know?

HOLGADO: I just know.

He replaces the receiver.

MOTHER: *(Gently.)* You look very tired.

HOLGADO: I feel very tired.

MOTHER: Maybe you should go to bed?

HOLGADO: Maybe I should.

MOTHER: *(Brightly.)* Should I run you a hot bath?

CONRAD: I don't want him to look after us…I want him to go away.

MOTHER: I won't have you speaking to poor Mr Zankovitch in that way. Now apologise, Conrad.

CONRAD: I'm very sorry Mister Holgado –

MOTHER: Mister Zankovitch.

HOLGADO: *(Slowly, to CONRAD.)* Zan-ko-vitch.

MOTHER: That's better. We're all friends now. I'll run your bath.

She exits.

CONRAD: I'm not really sorry.

HOLGADO: I'm not really Mr Zankovitch.

CONRAD is about to call out. HOLGADO puts his finger to his lips.

Ssh!

SCENE FOUR

The next afternoon. HOLGADO stands on a chair in the study. He lifts one of the framed display boxes of beetles from the wall. CONRAD stands in the hallway, waiting patiently beside the telephone. Hearing MOTHER's footsteps, he picks up the telephone receiver. MOTHER enters the kitchen.

CONRAD: Yes, this is Conrad Van der Bosch in apartment 19C, Marshal Podovsky Street…yes…yes…yes, I understand. Thank you very much for telephoning. Goodbye.

> *He replaces the receiver.*

MOTHER: Who was that on the telephone, Conrad?

CONRAD: It was the police, Mother.

MOTHER: The police?

CONRAD: They called to tell us that a tiger has escaped from the zoo.

MOTHER: *(Alarmed.)* A tiger…escaped?

CONRAD: Yes. A large Bengal tiger with bright green eyes and ferocious teeth.

MOTHER: Is it…is it dangerous?

CONRAD: Extremely dangerous. It hasn't been fed since this morning.

> *He smiles.*

Where is Mister Zankovitch?

MOTHER: In your father's study. He's very busy.

CONRAD: Doing what?

MOTHER: I don't know. He said he didn't want to be disturbed.

> *Anxiously, MOTHER opens the apartment door and peers outside – relieved not to see the tiger, she begins to prepare dinner. HOLGADO takes an object out of DOCTOR's desk – it is CONRAD's tiger growl*

box. HOLGADO *sits on the floor. He reads a label on the beetle display box.* CONRAD *walks to the study.*

HOLGADO: 'Ten varieties of native beetle.'

He uses the growl box to smash the glass of the beetle box.

Bark beetle…

He removes the beetle and eats it.

…very woody.

He laughs. CONRAD *opens the door.*

I said I didn't want to be disturbed…

Beat.

Oh. It's you…

He smiles.

CONRAD: What are you doing?

HOLGADO: None of your business.

He pulls another beetle from the board.

CONRAD: What's that?

HOLGADO: Click beetle. Want to see him fly?

He holds the beetle in his hands; it seems to make a loud clicking noise. HOLGADO *throws it up into the air, and catches it in his teeth.*

Crunch 'em down.

He smiles.

Stag beetle next, I think…

He eats another beetle.

CONRAD: A tiger has escaped from the zoo.

HOLGADO: *(Chewing.)* You think I'd believe that?

CONRAD: It's true. The police telephoned.

HOLGADO: You're lying. You're making it up.

CONRAD: Ask Mother if you don't believe me.

HOLGADO: I will.

He gets up from the floor. As an afterthought, he bends down, takes one more beetle from the box, and eats it defiantly. He stalks into the kitchen. CONRAD spots the growl box on the floor. He bends down, picks up the box and holds it triumphantly, allowing it to growl quietly. He hides the box behind his back and runs into the kitchen.

HOLGADO: I'm sorry to interrupt, Mrs Van der Bosch, when it's clear you're very busy.

CONRAD: Mister Holgado has been eating Father's beetles.

MOTHER: Don't tell tales, darling.

HOLGADO scratches at his teeth with a toothpick.

HOLGADO: Always telling such terrible, awful lies...I don't know why you don't just eat him yourself.

MOTHER: I beg your pardon?

HOLGADO: *(Flicking something out from his teeth.)* Ever find that the wings get caught between your teeth...?

He stops himself.

Talking of lies...Conrad, your little angel...he's been telling me all sorts of things to make the hairs stand up on my neck and my stomach churn over like there's rats in it, gnawing...

MOTHER: Have you been terrifying Mister Zankovitch, Conrad?

HOLGADO: Only with lies that couldn't possibly be the truth, they're so horrible.

CONRAD: He deserved it.

MOTHER: What did Conrad say?

HOLGADO: *(Laughing.)* He said there's a tiger...what escaped from the zoo. Have you ever heard such stories? I'm asking

you, how could we be expected to believe that a tiger could escape from the zoo? That it bit through its iron bars, bit the legs off the zookeeper so he couldn't run after it… then what, did it just walk out of the zoo? Is that what your little angel Conrad expects us to believe?

MOTHER: But the tiger did escape. The police telephoned to warn us. They spoke to Conrad.

CONRAD: See? I told you.

HOLGADO: *(Quietly.)* But how did the tiger escape?

CONRAD: The zookeeper left the cage door open.

HOLGADO: That was very stupid. Idiotic. I'd feed the zookeeper to the tiger, just to make a point.

CONRAD: *(Enjoying himself.)* But the tiger's not there, is he? He escaped.

HOLGADO: *(Pacing.)* What do we pay our taxes for? It's so the police can keep the tigers off the streets.

MOTHER: I quite agree.

HOLGADO: And where is the tiger now? That's my question for you. The city is grey, the tiger is orange, that should make it easy to spot, but no. What are the police doing?

MOTHER: I'm sure they're doing their best to catch it.

HOLGADO: But is it enough? Don't they realise how terrified some people are of tigers?

Distraught, he walks around the room pulling at his hair.

MOTHER: You're perfectly safe here.

CONRAD: No he's not. He's never safe…not with a tiger on the prowl.

HOLGADO hugs himself and moans loudly.

MOTHER: Now look what you've done to poor Mister Zankovitch.

CONRAD: It's not my fault if tigers want to eat him.

HOLGADO: We need to keep away from the windows…me and tigers don't get on.

MOTHER: I only like tigers when they are in the zoo. I can quite understand why you don't like tigers when they're roaming the streets.

HOLGADO: But it's more than that…

Beat.

CONRAD: His mother and father were killed by a tiger.

MOTHER: Conrad, what have I told you about telling stories?

HOLGADO: But it's true. Every word of it.

He whispers to CONRAD.

But how could you possibly have known?

CONRAD: *(Whispering.)* Anybody who knows anything about Mister Holgado, knows that his mother and father were killed and eaten by a tiger.

MOTHER: What are you saying…why are you whispering?

CONRAD: His mother and father were torn to pieces and eaten up…

Pointedly.

…like little bits of meat.

MOTHER: That's very unfortunate.

HOLGADO: Very unfortunate.

MOTHER: And very sad.

HOLGADO: Unbearably sad.

MOTHER: What…happened?

HOLGADO: I don't like to talk about it.

MOTHER: No. Of course not. I'm sorry.

CONRAD: His mother and father were very stupid people.

MOTHER: Conrad, don't be rude.

CONRAD: But they were stupid. They worried about everything except the things that really mattered. Every day his father said he didn't like noise and he didn't like untidiness…and his mother took pills for her nerves…

HOLGADO: She did.

CONRAD: And one day they went for a picnic…in a great forest…

HOLGADO: Stop…

CONRAD: …but they were still worrying about everything, worrying so much they didn't see the signs that read…

HOLGADO: …please!

CONRAD: …'Beware of the wild tiger!'

HOLGADO: We were sitting in a clearing, no harm to no one…me…and my mother and father…eating cake and sandwiches…

CONRAD: And in the sandwiches, the one thing tigers like more than anything –

HOLGADO: Anchovy and herring paste!

CONRAD: His mother and father didn't notice the eyes, peering out between the trees…

HOLGADO: Like orange light bulbs they were, all bright and glowing…ferocious eyes…

MOTHER: What did you do?

HOLGADO: What could I do… I had my mouth full of sandwich… I tried calling out, 'Tiger!'…but no one could hear me… I was muffled by anchovy and herring paste…

CONRAD: And then the tiger sprang out into the clearing…its great jaws open wide…

HOLGADO: Slavering it was…drooling…

CONRAD: It hadn't eaten any people for weeks and weeks… the anchovy and herring paste just made it nicer for the tiger…

MOTHER: And what happened to your mother and father?

CONRAD: By the time they saw the tiger it was too late.

HOLGADO moans.

His father was fat…

MOTHER: Conrad!

HOLGADO: It's true. He was a fat man.

CONRAD: With fat stumpy arms, and fat little legs…

HOLGADO: He couldn't run fast.

CONRAD: Not fast enough. The tiger pounced at him…

HOLGADO: No more. I'm begging you.

CONRAD: …it tore his stumpy little arms off…then it ripped his fat little legs off…then it bit off his big fat head…

MOTHER: Enough!

HOLGADO: It's true…it's all true.

MOTHER: But your mother…maybe she got away…maybe she wasn't eaten by the tiger after all?

CONRAD: *(Grimly.)* But she was eaten.

MOTHER: She was?

HOLGADO: She was.

He sobs.

Once a tiger gets a taste for a family…

CONRAD takes the growl box from behind his back and turns it upside down – it produces a loud and ominous growl. HOLGADO stops in his tracks, terrified.

What was that?

MOTHER: What was what?

Again, CONRAD turns the growl box.

HOLGADO: That.

MOTHER: Can tigers climb stairs?

HOLGADO: Oh yes. Or he could have come up in the elevator…they're very clever, they are…tigers.

CONRAD: And once a tiger gets a taste for a family…

HOLGADO: You mean…

A moment of realisation.

…it's the very same tiger that ate my mother and father?

Once more, CONRAD turns the growl box upside down to produce a loud roar.

MOTHER: Conrad! I won't have you terrifying poor Mister Zankovitch.

She takes the growl box from CONRAD.

CONRAD: *(Upset.)* The tiger's coming for you, Mister Holgado…and when he gets you, because he will, he's going to kill you and eat you…he's going to snap you up bit by bit…starting with your feet and working his way up…so you can keep on screaming right until…snap… snap…blood…bone…dead!

HOLGADO groans. CONRAD runs into his bedroom. Beat. He returns.

…and all because your mother and father were so stupid.

SCENE FIVE

Night. CONRAD is in bed. There is a loud clash of metal, as a knife and fork are sharpened. CONRAD sits up. He switches on his bedside lamp and stares hard at the wardrobe. The cuckoo clock chimes strangely in the silent apartment. The bedside lamp flickers.

CONRAD climbs out of bed and creeps across the floor to the wardrobe, avoiding the creaking floorboard. He knocks on the wardrobe door.

CONRAD: Are you inside, Mister Holgado?

> *Beat.*

> Mister Holgado…are you in there?

> *Silence. CONRAD counts the steps back to his bed.*

> One…two…three…four…

> *With a creak, the wardrobe door swings open to reveal HOLGADO standing inside, holding the eye box and his two suitcases. CONRAD turns in horror. Outside, there is an ominous rumble of thunder.*

HOLGADO: Hello, Conrad.

> *CONRAD jumps into bed, and sits with the bedclothes pulled up under his chin. The bedside lamp flickers and goes out. When the light comes on again HOLGADO has moved a step towards the bed, holding his fork. The lights go out again – when they come on, HOLGADO is another step closer to the bed, holding his knife. The lights go out – when they come on again, HOLGADO has tucked in his napkin, and stands over CONRAD's bed.*

> This has gone on long enough.

CONRAD: If you don't go away…I'll set my tiger on you.

HOLGADO: You don't have a tiger. Not any more. I let him out.

CONRAD: The tiger that escaped from the zoo will come. He'll bite your legs off.

HOLGADO: You're a very nasty little boy, you are. Cruel.

> *He advances on CONRAD.*

CONRAD: Mother!

HOLGADO: She won't come. Why do you think she let me stay in the first place?

CONRAD: I don't know.

HOLGADO: It's obvious, isn't it? She wants me to eat you.

CONRAD: No she doesn't.

HOLGADO: Maybe your mother and father don't like you very much.

CONRAD: They do like me.

HOLGADO: Maybe they've been hoping for me to come all along.

He looks at his pocket watch.

That's enough talking…if I'm going to eat every last bit of you by morning, I need to get started.

He scrapes the knife and fork together, sharpening them, singing to himself. Suddenly, and with a volume that shocks HOLGADO, CONRAD screams…

CONRAD: Mother! Help!

Silence.

HOLGADO: You see? What did I tell you?

CONRAD: *(Suddenly.)* Let's play a game…

HOLGADO: *(Thrown.)* What?

CONRAD: …hide and catch. You close your eyes and count to ten…very, very slowly…

HOLGADO: And then I come and find you?

CONRAD: Yes. Cover your eyes.

HOLGADO covers his eyes, peering through his fingers.

Don't cheat.

97

HOLGADO turns his back.

Now count to ten.

HOLGADO begins counting. CONRAD walks away, quietly counting to ten. As soon as CONRAD's back is turned, HOLGADO opens his eyes and follows behind, taking his eye box and the two suitcases with him. CONRAD tiptoes into the study and hides under the desk.

HOLGADO: Ten.

He peers beneath the desk.

CONRAD: Did you cheat?

HOLGADO: Yes.

Beat.

I've got you now.

MOTHER stalks into the kitchen from the offstage hallway, wearing a dressing gown. She picks up a frying pan from the stove, which she hides behind her back as she walks towards the study.

HOLGADO places the eye box on the desk.

I've wasted enough time…the sooner I eat you, the sooner I can get back to my house on the hill…

He presses a button on the side of the box and the glowing eye begins to rise from within.

MOTHER enters.

MOTHER: Conrad…? I thought I heard a noise.

CONRAD smiles. HOLGADO hurriedly pushes the glowing eye back inside the box and smiles at MOTHER.

Mr Zankovitch…

HOLGADO: I thought I heard a noise as well. Maybe it's cockroaches…or rats behind the walls?

MOTHER: I thought…

HOLGADO: Yes?

MOTHER: I thought it might have been Mister Holgado.

CONRAD attempts to speak, but HOLGADO puts his hand over the boy's mouth, unseen by MOTHER.

But Mister Holgado knows better than to come to our apartment to eat my little Conrad…because he knows what I will do if he does.

HOLGADO: What will you do?

MOTHER holds up the frying pan.

MOTHER: I will hit him…and hit him…and hit him…until blood comes out…

CONRAD grins.

Your father isn't here, Conrad, so I have to take charge now.

Beat.

What were you doing with your box, Mr Zankovitch?

HOLGADO: *(Suddenly.)* Free eye tests for the Van der Bosch family!

MOTHER: What?

HOLGADO: Your turn first, Mrs Van der Bosch.

MOTHER: Me?

HOLGADO takes the frying pan from MOTHER's hand and pushes her into a chair.

HOLGADO: Comfortable, are you?

MOTHER: Yes…thank you.

HOLGADO straps MOTHER's wrists to the arms of the chair.

HOLGADO: Not too tight?

MOTHER: A little tight…

HOLGADO opens a drawer in the box and puts on a pair of magnifying spectacles. He takes out a tray of glass eyes and a large and terrifying surgical instrument. MOTHER flinches.

I do already have a pair of reading spectacles.

HOLGADO: Yes, but have you been tested for glass eyes? That's what I'm asking you. Doesn't matter if you've got spectacles, or if you haven't got spectacles…you never know when you're going to need your eyes replaced with glass ones.

Beat.

How many spikes can you count on this eye gouge?

MOTHER: Twelve.

HOLGADO: Twelve…

Menacingly.

…or is it thirteen?

He holds up the eye gouge, threateningly.

Twelve. You're quite right. Very good. Now can you see…

He holds up a knife.

…this?

MOTHER: It looks like a knife.

HOLGADO: Quite right. Very good. And this?

He holds up a fork.

MOTHER: Is it a fork?

HOLGADO: A fork. You're very good at this.

MOTHER laughs, delighted.

But some people, with perfectly good eyes, can't see what's right in front of them.

MOTHER: How terrible.

HOLGADO takes out his napkin and tucks it into his shirt, licking his lips. MOTHER grows suspicious.

What are you doing?

HOLGADO: I think you know.

He sharpens his knife and fork and sparks fly.

I'm going to eat little Conrad.

MOTHER tries to move her arms.

MOTHER: Conrad…I can't get out.

HOLGADO advances on CONRAD.

HOLGADO: Your father's gone. Your mother's trapped. There's no one that can save you.

He runs his finger along the blade of the knife.

And now it's time for Mister Holgado to get to work.

MOTHER: *(Hysterically.)* But there isn't a Mister Holgado. He doesn't exist!

Pause. CONRAD and HOLGADO turn to MOTHER.

There never *has been* a Mister Holgado…

CONRAD: *(Triumphantly.)* But you said there was…you said he came and took my tiger away.

MOTHER: I know what we said.

CONRAD: Did you tell an untruth?

MOTHER: Yes. We lied. And now this can all come to an end.

Beat.

CONRAD: *(Defiantly.)* I knew there wasn't a Mister Holgado… not really.

Beat.

HOLGADO: Oh…but there is.

In a quick and fluid movement he removes his overcoat, to reveal a bloodied butcher's apron beneath.

MOTHER: *(Terrified.)* Mr Holgado.

Quietly.

If only your father were here.

HOLGADO: But would it be so bad if Doctor Van der Bosch didn't come home?

MOTHER: What do you mean?

HOLGADO: Don't say you haven't thought about it...about something terrible happening to him.

MOTHER: Well...

HOLGADO: Yes?

MOTHER: I sometimes think...

HOLGADO: Yes?

MOTHER: *(A sudden outpouring of anger.)* ...I sometimes think how nice it would be if it was just Conrad and I living in the apartment...if Doctor Van der Bosch had met with an awful accident. Accidents are always happening. If he stumbled at the zoo and fell face down in the penguin pool and was too weak to pull himself out again... and drowned...and all because he didn't have time for breakfast. Conrad and I would be very happy here on our own...and we could turn my husband's study into a playroom, with hundreds and hundreds of toys...

CONRAD: *(To HOLGADO.)* And not toys with blood on them.

MOTHER: ...and we could burn his collections of beetles...and smash up his expensive artefacts...

Angrily, HOLGADO presses the button on the side of the eye box. The illuminated eye rises, and the sides of the box fall down, allowing a flood of bruised and bloodied toys to tumble out onto the study

floor. The back of the box is plastered with countless photographs of smiling children.

CONRAD: *(A whisper.)* All the children he's killed!

HOLGADO: It'll be over before morning. I'll just eat him and then I'll be gone. Maybe you could have another child. A better child.

MOTHER: *(Quietly.)* But I like Conrad.

HOLGADO: Why don't you close your eyes?

MOTHER: You're scaring him.

CONRAD: I'm not scared.

HOLGADO: Why not? You should be terrified.

CONRAD picks up one of the suitcases, trying to protect himself.

What are you doing with that case?

CONRAD: What's in it?

HOLGADO: Don't open it…that's none of your business what's in there.

CONRAD opens the suitcase, and DOCTOR's clothes fall out onto the floor.

CONRAD: Father's clothes!

MOTHER: What have you done with my husband?

CONRAD: What's in the other suitcase?

MOTHER: It's probably your father…chopped into tiny little pieces.

HOLGADO roars and CONRAD steps away from the suitcase. HOLGADO gathers the clothes and shuts them inside the case. CONRAD picks up an electric lamp and attempts to defend himself with it.

HOLGADO: That doesn't scare me. I can crush electric light bulbs with my bare hands.

CONRAD climbs on the couch.

MOTHER: Don't stand on the chairs.

HOLGADO climbs onto the couch.

Stop it at once!

CONRAD drops the lamp and a large shadow of HOLGADO is thrown against the wall. MOTHER yells.

HOLGADO: He's braver than I imagined. Most children have given up by now.

CONRAD runs to DOCTOR's desk, and climbs on top. He unhooks a painted tiger mask from the wall.

MOTHER: Be careful. You'll break something. You know how angry your father would be…

Beat.

…if he wasn't dead.

CONRAD picks up a vase.

Be careful of the ornaments!

CONRAD throws a small vase at HOLGADO, who dodges out of the way. CONRAD picks up a small artefact, which he throws at HOLGADO, hitting him squarely on the head.

MOTHER: Hit him harder!

CONRAD throws another artefact, which misses HOLGADO.

HOLGADO: I'm going to enjoy eating you.

He advances on CONRAD, who up-ends the drawer of glass eyes, which shatter down on the table, bouncing onto the floor. HOLGADO slips on the eyes and comes crashing to the ground. He staggers to his feet.

MOTHER: Conrad…quickly! Do something.

CONRAD runs into the kitchen, pursued by HOLGADO. MOTHER follows behind, still strapped to the chair. CONRAD opens a cupboard and takes out a jar.

HOLGADO: *(Laughing.)* And what are you going to do with that?

CONRAD unscrews the lid. HOLGADO sniffs the air.

CONRAD: *(Triumphantly.)* Anchovy and herring paste.

HOLGADO backs away. CONRAD takes out a handful of the fish spread. HOLGADO holds up the eye gouge.

MOTHER: Throw it at him, Conrad…throw the whole pot!

A moment of indecision. Suddenly, HOLGADO lunges at CONRAD. CONRAD steps to one side and HOLGADO lurches past him. CONRAD jumps onto HOLGADO's back and smears his face with anchovy and herring paste.

HOLGADO: My eyes!

CONRAD releases MOTHER from the chair.

CONRAD: We can hide in my bedroom.

MOTHER picks up another frying pan. CONRAD and MOTHER run to the bedroom. MOTHER takes out her key, and locks the door from the inside. HOLGADO wipes the fish paste from his eyes and exits through the offstage hallway. His door slams, off.

MOTHER: That was Mister Holgado's door slamming.

Beat. She takes another key out of her pocket.

Maybe if we locked his door. Then we could call the police?

CONRAD: It might be a trick.

Cautiously, MOTHER opens the door and looks outside.

MOTHER: There's nobody there.

CONRAD: Quickly, Mother.

MOTHER runs into the kitchen, and exits through the offstage hallway. She returns hurriedly.

MOTHER: It's done. I've locked it.

CONRAD: Quick…the glass.

MOTHER takes the glass from the bedside table and passes it to CONRAD. He holds the glass against the wall, listening.

MOTHER: Can you hear anything?

CONRAD: Nothing.

MOTHER: Maybe he's given up?

CONRAD: He won't give up.

MOTHER: Whatever shall we do, Conrad?

Fairground music can be heard from HOLGADO's room.

CONRAD: I'm scared, Mother.

MOTHER holds CONRAD's hand.

MOTHER: Don't be scared. We must both be very brave. And when this is all over…

CONRAD: Yes?

MOTHER: I think it might be a very good idea for you to play with other children…and to go outside every now and then.

CONRAD smiles.

CONRAD: What are we going to do?

MOTHER: Maybe we can get out. Maybe we can escape?

They are startled by a loud creak.

CONRAD: It's too late.

The wardrobe door opens and HOLGADO steps out from inside.

MOTHER: How did you get into the wardrobe?

HOLGADO: Ask me no questions, I'll tell you no lies.

MOTHER: I will not let you eat little Conrad.

HOLGADO: And what are you going to do to stop me?

MOTHER: I'll call the police.

She unlocks the door and runs into the study, followed by CONRAD and HOLGADO. She picks up the telephone and dials.

MOTHER: Hello? Police? This is Mrs Van der Bosch, apartment 19C, Marshal Podovsky Street…a very strange man is trying to murder my son…

HOLGADO: No, don't telephone.

He pulls out the telephone wire.

MOTHER: I'd feel much safer if the police were here.

She holds up the frying pan.

HOLGADO: What are you going to do with that frying pan?

MOTHER: I'm going to beat your brains out.

HOLGADO: You're not being very sensible about this. There's no reason we should fall out. I only want to eat Conrad, I don't want to eat you.

MOTHER: But that isn't the point. Is it?

HOLGADO: Isn't it?

MOTHER: No. It isn't.

She hits HOLGADO with the frying pan.

HOLGADO: *(Icily calm.)* Why did you do that?

MOTHER: I want you to stop.

She breaks down, upset and frightened.

Please make him go away!

CONRAD picks up the tiger mask and puts it on.

CONRAD: Once upon a time there was a gigantic tiger…

HOLGADO: *(Chillingly.)* I've had enough of tigers.

Outside, the thunder grows in volume. HOLGADO stalks towards CONRAD, who backs out into the hallway, growling as he goes. He runs into the kitchen and out through the offstage hallway. HOLGADO follows behind, taking the suitcases with him. HOLGADO's door can be heard slamming loudly, the noise echoing round the apartment. The thunder rolls. The lights flicker and go out and the apartment is plunged into darkness. MOTHER lets out a blood-curdling scream.

Silence.

CONRAD enters slowly.

MOTHER: Conrad!

She sobs. CONRAD runs to her and she hugs him. Outside it begins to rain. The lights come on again.

CONRAD: It's all right, Mother.

MOTHER: I thought you'd been…

Beat.

Where is Mister Holgado?

CONRAD: He got tangled up in the curtains…he hit his head… he fell out of the window…

MOTHER: Is he hurt? Is he dead?

CONRAD: *(Quietly.)* I didn't want to look.

MOTHER: No, of course not. A terrible thing for a little boy to see…a man smashed to pieces on the pavement. All the blood and…gore. Maybe I should go and look out of the window, just to make sure?

The door buzzer sounds.

Maybe it's him? Maybe it's Mister Holgado? Maybe he's alive after all?

She picks up the frying pan.

Conrad, open the door…and I'll hit him with the pan…

MOTHER stands beside the door, the frying pan raised above her head. Beat. She lowers the frying pan.

… Or it might be the police.

CONRAD: Or the zookeeper.

MOTHER: Or the tiger.

She raises the frying pan again. The buzzer sounds again.

CONRAD: Who is it?

DOCTOR: *(Off.)* It's me. Doctor Van der Bosch.

MOTHER: But Doctor Van der Bosch drowned in the penguin pool.

DOCTOR: No he didn't.

MOTHER: Or he was torn to bits by the tiger.

DOCTOR: No he wasn't.

CONRAD: It sounds like Father.

Cautiously, MOTHER opens the door.

MOTHER: Darling?

DOCTOR enters, a shadow of his former self.

DOCTOR: Good evening, my dear. Good evening, Conrad.

CONRAD: Father?

MOTHER: Where have you been?

DOCTOR: I don't know.

MOTHER: You don't remember?

DOCTOR: I have a bump on my head.

MOTHER: Does it hurt?

DOCTOR: I don't remember.

Beat.

I've lost my hat.

MOTHER hands DOCTOR his hat. He smiles. MOTHER takes an ice pack from the ice box, and holds it to DOCTOR's head.

A most surprising thing has just happened to me...

MOTHER: Surprising?

DOCTOR: I was walking along the road, when I saw a Bengal tiger, standing on the pavement in front of me.

CONRAD: You saw the tiger? Really?

DOCTOR: As clearly as I can see you now. I thought he was going to eat me.

MOTHER: What happened?

DOCTOR: I had a fortunate escape. Just as the tiger was about to spring at me, a peculiar thing occurred. A man fell out of the window above me, and landed on the ground in front of the tiger. It was Mister Zankovitch –

MOTHER: It wasn't really Mister Zankovitch.

CONRAD: It was Mister Holgado, Father.

DOCTOR: It was, was it? So he finally came?

CONRAD: Yes.

DOCTOR: A very strange looking man...with fox-sharp teeth. I should have guessed.

CONRAD: What happened to Mister Holgado, Father?

DOCTOR: He screamed, 'help, please don't eat me!' But of course, the tiger paid no attention...it pounced at Mister Holgado and ripped the man into tiny little pieces.

CONRAD: Well I'm not sorry.

MOTHER: Neither am I.

Quietly.

Was there much blood?

DOCTOR: There was…but…but it was washed away in the rain.

MOTHER: I do hate mess.

CONRAD: What happened to the tiger?

MOTHER: I expect it went back to the zoo.

CONRAD: Yes.

DOCTOR: Yes.

Beat.

MOTHER: I don't think you need to worry about Mister Holgado any more.

CONRAD smiles.

You must be hungry.

DOCTOR: Ravenous as a tiger.

MOTHER laughs nervously. DOCTOR sits at the table.

CONRAD: Should we telephone the police to tell them that Mister Holgado has been eaten, Mother? Or should we telephone the zoo?

MOTHER: Maybe it would be best if we didn't telephone anyone?

The telephone rings. MOTHER answers, anxiously.

Hello? Yes, this is Mrs Van der Bosch, apartment 19C, Marshal Podovsky Street…

DOCTOR takes HOLGADO's battered hat out of his jacket pocket.

DOCTOR: Mister Holgado's hat…it dropped off when he fell out of the window. Perhaps you might like to keep it…as a souvenir?

CONRAD takes the hat and smiles.

MOTHER: *(Into the telephone.)* Yes, I did call you a few minutes ago…it was a mistake…of course, nobody was trying to murder my son…it was just…a terrible…mistake…

She replaces the receiver.

Police.

She picks up a cloth and begins to wipe the name 'Holgado' from the wall.

Your father is home. Mister Holgado has been eaten by the tiger…

DOCTOR: The tiger is back in the zoo.

MOTHER: Is it?

DOCTOR: I expect so.

MOTHER: Then everything has returned to normal.

She smiles. DOCTOR is distracted by something on the floor. Suddenly he gets up from his chair and kneels down.

MOTHER: Darling?

CONRAD: Father?

DOCTOR picks up a cockroach and holds it to the light. Beat. He crunches down the insect. CONRAD stares anxiously at MOTHER, who gives him a supportive squeeze of the hand. CONRAD smiles.